William Henry Hunt
Country People

In memory of William Oliver Clarke (1943–2010)

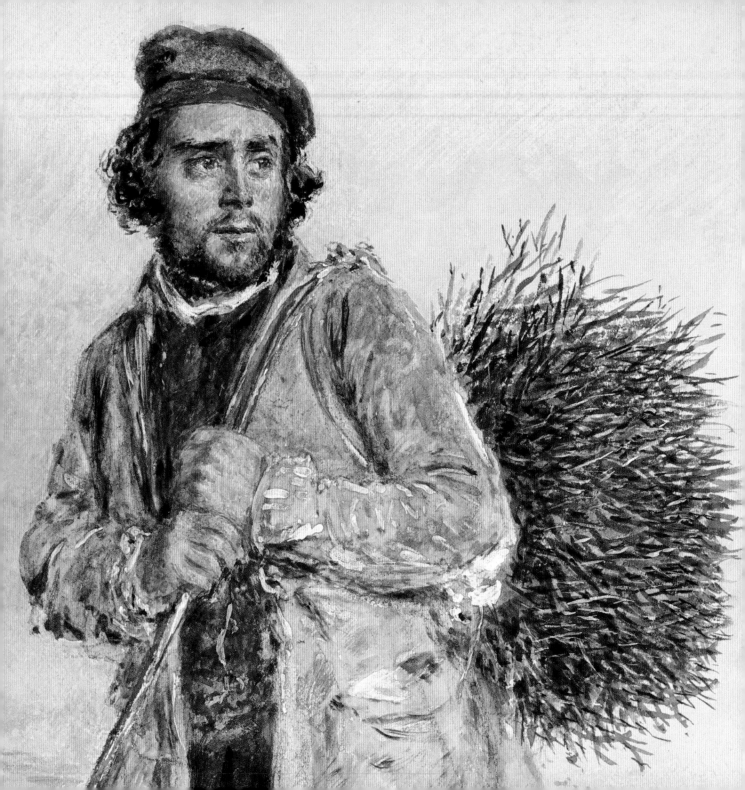

William Henry Hunt
Country People

JOANNA SELBORNE AND CHRISTIANA PAYNE

THE COURTAULD Gallery

First published to accompany

William Henry Hunt: *Country People*

The Courtauld Gallery, London, 24 June – 17 September 2017

The Courtauld Gallery is supported by the Higher
Education Funding Council for England (HEFCE)

HIGHER EDUCATION *hefce*
FUNDING COUNCIL FOR ENGLAND

ISBN 978 1 911300 23 6

British Library Cataloguing in Publication Data

A catalogue record for this book is available from the British Library

Produced by Paul Holberton Publishing
89 Borough High Street, London SE1 1NL
www.paul-holberton.net

Designed by Laura Parker

Printing by Gomer Press, Llandysul

FRONT COVER: *The Head Gardener* (cat. 10), detail
BACK COVER: *The Poacher* (cat. 6), detail
FRONTISPIECE: *The Broom Gatherer* (cat. 18), detail
PAGE 5: *The Gardener* (cat. 13), detail
PAGE 8: *Girl with a Sheaf of Corn (The Gleaner)* (cat. 15), detail
PAGE 10: *The Gamekeeper* (cat. 5), detail
PAGE 20–21: *The Maid and the Gamekeeper* (cat. 17), detail

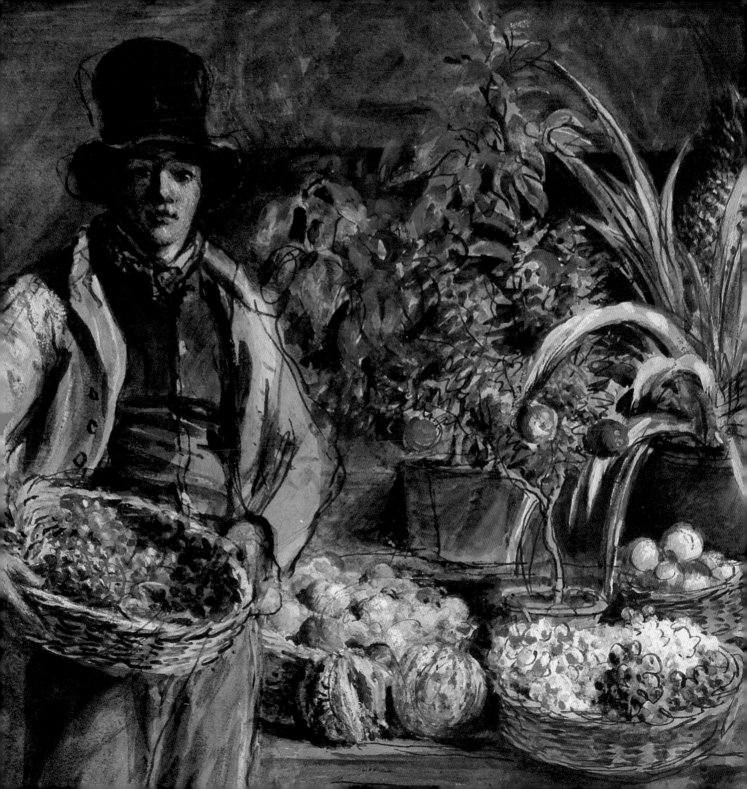

Supporters

William Henry Hunt: Country People is sponsored by
The International Music and Art Foundation

Further generous support has been provided by
The Richard McDougall Fund

The Gilbert and Ildiko Butler Drawings Gallery was made
possible by a major grant from Gilbert and Ildiko Butler,
with further generous support from:

Anonymous, in memory of Melvin R. Seiden
The International Music and Art Foundation
Lowell Libson Ltd
Diane Allen Nixon
Niall Hobhouse
Andrea Woodner
Elke and Michael von Brentano
Tavolozza Foundation – Katrin Bellinger
The Samuel Courtauld Trust

Foreword

The Courtauld Gallery's drawings collection was fully established in 1952 when Sir Robert Witt (1872–1952), one of the three founders of the Courtauld Institute of Art, endowed the institution with his outstanding collection of approximately 3,000 drawings. In 1982 his son, Sir John (1907–1982), enhanced this legacy with the bequest of a group of some 25 works by the watercolour painter William Henry Hunt, alongside other drawings. Ranging across the artist's career, the gift testified to John Witt's deep appreciation of Hunt, which had also led him to compile the standard catalogue of reference on the artist. The Gallery now holds some 39 works by Hunt, including *The Head Gardener* (cat. 10), acquired in 2011 in memory of William Clarke, the Gallery's former Conservator of Works on Paper, to whom this exhibition is dedicated. That this intriguing work should have formed the springboard for the present exhibition, rather than the artist's more popular still lifes, reflects one of the central aims of the Gilbert and Ildiko Butler Drawings Gallery. Specifically, its programme seeks to enrich our understanding of the history and practice of drawing by examining particular questions and overlooked episodes.

Focused exhibitions of this sort have been squeezed out of the programming of many museums. The reasons for this are understandable. Nevertheless, the trend represents an impoverishment of the public mission of museums, in particular their essential role in researching and presenting for public benefit the great variety of the history of art beyond those names and movements whose bankable qualities disproportionately shape our understanding of the past. We are therefore especially grateful to our supporters for enabling this wider mission to flourish at The Courtauld Gallery. Gilbert and Ildiko Butler funded the construction of the Drawings Gallery, along with other generous contributing donors named opposite. We are enduringly grateful to them. The rich, varied and immensely stimulating programme of the Drawings Gallery is generously supported by the International Music and Art Foundation, and we extend our warm thanks to its far-sighted Trustees. We also gratefully acknowledge the support for this exhibition received from the Richard McDougall Fund.

I am deeply indebted to Joanna Selborne, former Curator of Drawings and Prints at the Gallery, for leading this project, and doing so with such commitment and care. Thanks are also due to Christiana Payne for her expert contribution. I would like to record my thanks to Shirley Fry and her family for their encouragement, kindness and hospitality. Finally, on behalf of the Courtauld, I extend my thanks to the private owners and the colleagues in other museums who so readily agreed to share works in their care.

ERNST VEGELIN VAN CLAERBERGEN
Head of The Courtauld Gallery

William Henry Hunt and Country People

JOANNA SELBORNE

William Henry Hunt (1790–1864) is one of the key figures in nineteenth-century English watercolour painting. His work was extensively collected in his lifetime, particularly the intricate still lifes of flowers, fruit and feathers that earned him the nickname 'Bird's Nest' Hunt. While his large rural genre subjects have always been highly prized, the single figure studies of country people are less well known. Hunt's representations of such characters and types in a time of rapid social and agricultural development raises questions about their identity and status, and the changing relationship with rural labour and the land during his lifetime – changes that are reflected also in the literature of the period.

Hunt was born in London, in the vicinity of Covent Garden, where his father worked as a maker and decorator of tin ware, mostly for the local theatres. Disabled from birth, he was unfit for physical work but his early talent for drawing led to a career as an artist. At the age of fourteen he was apprenticed to the leading landscape watercolourist and drawing master John Varley, a central figure in a wide circle of artists that included J.M.W. Turner as well as John Linnell and William Mulready, with whom Hunt formed a close friendship. Varley's teaching had a lasting effect on him through their shared interest in working from nature. A passion for the theatre and a spell painting scenery gave Hunt insights into the world of stage design and painterly effects.

In 1807 Hunt exhibited three oil paintings at the Royal Academy, entering the Royal Academy Schools the following year. In 1814 he exhibited for the first time at the Society of Painters in Water-Colour, later known as the Old Water-Colour Society (OWCS). Critical to his progress was the patronage of Dr Thomas Monro, whose informal drawing academy he attended (and of which Turner, Thomas Girtin and Varley were early members), both at Monro's house near the Strand and at Bushey, near Watford. Pupils copied works by Gainsborough, J.R. Cozens and Canaletto, from whom Hunt derived a lively reed pen and ink and wash technique. The patronage of the Duke of Devonshire at Chatsworth, Derbyshire, and of the 5th Earl of Essex at Cassiobury Park, near Bushey, widened his horizons and helped to launch his career. In 1826 he was elected a full member of the OWCS, after which he devoted himself almost exclusively to painting in watercolour.

Hunt's physical disability drove him to choose subjects close at hand. In later years poor health prevented him from drawing in the open air, hence the preponderance of interior settings, particularly barns and cottages, and his staged comic portraits of children that appealed to the Victorian sense of humour. By the 1840s his watercolours were being engraved and were thus reaching a much wider public. Ruskin, who took lessons from Hunt in 1854 and 1861, extolled his innovative use of bodycolour and gradated colour techniques, which would indeed inspire such well-known successors as J.F. Lewis and the Pre-Raphaelites. His oeuvre thus defines the transition from the eighteenth-century style of clean, transparent washes to the bolder use of the medium that characterises watercolour practice in the Victorian period.

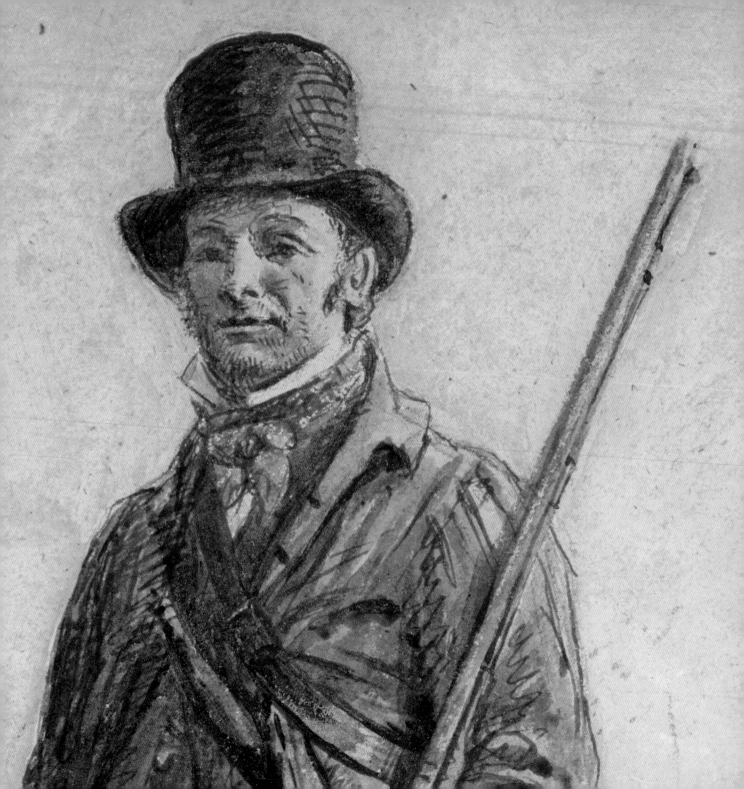

William Henry Hunt and 'Rustic' Figure Studies

CHRISTIANA PAYNE

William Henry Hunt's finely crafted figure studies open a window on to a vanished world of poachers and gamekeepers, millers and maltsters, estate gardeners and labourers. These were the people whose occupations supported – or in the case of poachers, undermined – the hierarchical rural society of the first half of the nineteenth century. Hunt portrayed them with dignity and respect, giving them a degree of individuality which makes the paintings look like portraits. Sometimes this is an illusion – he often used his own family and friends as models – but in several cases we know for sure that his subjects were authentic, even named, representatives of this particular group.

Depictions of country people, whether in art or in literature, were plentiful in early nineteenth-century England. In the later decades of the eighteenth century, influential poets had drawn attention to the plight of the rural poor. Oliver Goldsmith's *The Deserted Village* (1770) created an idyllic vision of village life, which provided many useful subjects for artists. He set it in the past, however, before enclosure, landscape improvement and the sale of estates to nouveaux riches had taken over the countryside and, as he saw it, dispossessed the peasantry. George Crabbe's *The Village* (1783) emphasised the other side of the coin, presenting a vivid picture of contemporary villagers as sullen and exploited, worn down by their labour. William Wordsworth stressed the common humanity which united rich and poor alike in his set of poems *Lyrical Ballads* (1800). Wordsworth stated that he chose to write about "humble and rustic life" because in that situation "the

essential passions of the heart find a better soil in which they can attain their maturity, are less under restraint, and speak a plainer and more emphatic language".[1] The early nineteenth century saw the emergence of two 'peasant poets', Robert Bloomfield and John Clare, who wrote from the perspective of those who actually worked on the land. Meanwhile, the journalism of the radical author William Cobbett encouraged a sympathetic interest in the living and working conditions of the countryside. His *Rural Rides*, originally published in the early 1820s and collected into one volume in 1830, railed against the corruption and insensitivity of the rich, and highlighted the effects these had upon the rural poor, who lacked the basic necessities of life.

Portrayals of country people could, therefore, be either disturbing or comforting to the wealthier members of society who bought paintings and visited exhibitions. On the one hand, they were reminders of recent social upheavals and threats to peace and property. In the wake of the French Revolution, distress repeatedly led to riots and demands for radical reform. An economic depression after the end of the Napoleonic Wars in 1815 led to unrest in town and countryside. Sporadic outbreaks of rick-burning and machine-breaking in the years that followed became particularly widespread in 1830, the year of the so-called 'Swing' riots. Anonymous threatening letters, signed 'Captain Swing', raised the spectre of revolutionary bloodshed. The Poor Law Amendment Act of 1834, which made entry into the workhouse obligatory before poor relief could be granted, sparked further riots. It was

11

becoming increasingly difficult to maintain the idea of the countryside as a stable, happy place. On the other hand, conditions in the cities might be even worse. Depictions of rural figures could suggest that the old values of contentment and deference survived in the countryside, at a time when the factories and expanding towns created by the industrial revolution were seen as hotbeds of discontent and potential revolutionary activity.

Painted studies of 'rustic figures' were popular in the early years of the Old Water-Colour Society, in the work of its founders and early exhibitors William Henry Pyne, Robert Hills, Joshua Cristall and Thomas Uwins (fig. 1).[2] Starting in 1802, W.H. Pyne published aquatints of hundreds of groups of "small figures for the embellishment of landscape" in his *Microcosm: A Picturesque Delineation of the Arts, Agriculture and Manufactures of Great Britain*. He followed this up with two further publications, *Etchings of Rustic Figures for the Embellishment of Landscape* (1815) and *Rustic Figures in Imitation of Chalk* (1817). Cristall and Uwins made many watercolour studies of country labourers, and particularly of gleaners – the poor, very often children, who were allowed to pick up the stalks of wheat left behind when the reapers had finished their work at harvest time. Their life studies are clear-eyed in their representation of the facts of country life, showing child labourers with ragged and makeshift clothing, but these were usually prettified and sanitised when they were translated into exhibition works for sale. Critics commented on the health and beauty that was to be found in English villages, and the contentment and innocence displayed in these images. Such qualities were appreciated all the more at a time when the appalling living and working conditions in towns and factories were becoming well known. Pyne even described Cristall's figures as "selected from sequestered villages, yet uncontaminated by the vicinity of manufactories".[3]

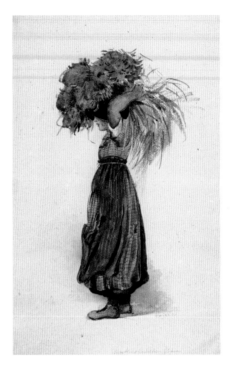

FIG. 1
Thomas Uwins
A Buckinghamshire Gleaner
Watercolour over graphite,
300 × 203 mm
Private collection

William Henry Hunt would have seen watercolours by Hills, Cristall and Uwins at exhibitions in his early years. His own rustic figure studies – or perhaps we should call them rustic portraits – were evidently studied from life, but he seems, on the whole, to have avoided tackling subjects that implied overt social comment. In the list of his exhibited works, only one is entitled *The Gleaner* (1832), although he showed many works with more generic titles such as *Peasant Girl*.[4] Stonebreakers and poachers were, like gleaners, further reminders of rural poverty and distress: stonebreaking was the task given to the poor in return

for parish relief, and poaching was the illegal occupation of many country labourers, who risked severe penalties, including transportation to Australia, when they trapped rabbits or pheasants to feed their families. Hunt's *Poacher* of 1825 (cat. 6) is a rare example in his work: he did not show another painting with this title until 1857. Similarly, his recorded exhibits do not include any entitled 'A Stonebreaker'. Cat. 16, bearing this title, was either not entered at all or exhibited under a different title. Hunt exhibited paintings of *The Mendicant* in 1831 and *A Mendicant* in 1833, and it is possible that he preferred this less challenging title for his depiction of a poor, though dignified, old man engaged in a back-breaking task. Hunt's portrayal of the subject is very different from Edwin Landseer's oil painting *The Stonebreaker and his Daughter* of 1830 (fig. 2), which emphasises the exhaustion and infirmity of the elderly worker, made even more poignant by the contrast with his fresh-faced young daughter.

Rather than focus on examples of rural poverty, Hunt produced many portrait-like images of servants in the 1820s. These were the indoor or outdoor servants attached to large houses, who made up a substantial proportion of the non-elite inhabitants of the countryside. They were not necessarily poor: there was enormous variation in the status and income of servants, and the head gardener and the head gamekeeper (like the butler and the housekeeper) were aristocrats of the servant world, highly valued for their skills and given responsible positions and relatively high salaries. Landowners, presumably keen on hunting themselves, often had their keepers portrayed in substantial oil paintings, either with their master or alone. Sir George Beaumont, for example, commissioned David Wilkie to paint a portrait of his head keeper in 1811, and Sir Walter Scott had one of his gamekeeper, Tom Purdie, painted by Charles Robert Leslie in 1824.[5] Groups of servant portraits were also common in this period, those at Erddig and Knole

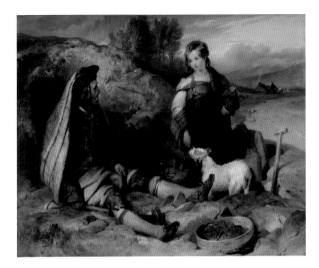

FIG. 2
Edwin Landseer
The Stonebreaker and his Daughter, 1830
Oil on panel, 45.7 × 58.4 cm
Victoria and Albert Museum, London

being the best known. As Giles Waterfield and Anne French have argued, they reinforced loyalty on both sides of the master-servant divide, particularly important at a time of revolutionary threats to the social structure.[6] They were often hung in the Servants' Hall of the house, where they would remind their viewers of the proper demeanour of loyal employees. At the same time, the commissioning of portraits recognised the individuality of each member of staff and often reflected genuine affection on the part of their employers.

As far as is known, Hunt began painting his small-scale single-figure studies in the early 1820s, when he was working for two landowners, the 6th Duke of Devonshire and the 5th Earl of Essex. Initially, they were all portraits of identifiable individuals, and they seem to have come about as a by-product of commissions for watercolours of the interiors of their respective mansions, Chatsworth

House and Cassiobury House. At Chatsworth, Hunt made a series of portraits of the indoor servants, which are still in the Devonshire collection – the groom of chambers, the butler (fig. 3), the footman and the housekeeper.[7] Hunt seems to have been more interested, however, in the outdoor servants and the craftsmen who worked on and around these large estates – the gamekeepers, gardeners, millers and maltsters. Brought up in the tradition of the Picturesque, he was better suited to depicting the interiors of barns and cottages, such as the one in *Kitchen Interior with Young Man sitting by the Fire* (cat. 4), with their broken textures and earthy colours, than those of grand halls and drawing rooms. The correspondingly 'rustic' features of clothing and attitude also appealed to him more, it seems, than the formality of the grand aristocratic sitter or the indoor servant.

Hunt first exhibited watercolours of rustic figures, one entitled *Gamekeeper* and the other *The Miller* in 1824. A reviewer, probably W.H. Pyne, confirms that the former was a portrait, stating that it was "a coloured study of a gamekeeper in the service of the Earl of Essex … a very original and masterful example of richness and effect".[8] It is natural to assume that such portraits would have been commissioned by their employers, but this was not always so. Watercolours of a keeper and a miller at Cassiobury were included in the sale of Hunt's works at Christie's after his death, so presumably they had remained in his collection and never entered that of the Earl of Essex.[9] Instead of working exclusively for these patrons, Hunt seems to have found that there was a ready market for small-scale portraits of estate servants. In the following year, 1825, he exhibited paintings of two gamekeepers, a gardener and a poacher (cat. nos. 5–7, 10).

Hunt's gamekeepers were particularly popular. *A Gamekeeper in the Service of Charles Dixon, Esq.* was shown in 1826 and *A Gamekeeper from Nature* in 1828. These paintings evidently catered to a widespread interest in field sports on the part of visitors to the Old Water-Colour Society exhibitions. Hunt was, at the same time, applying his talents to the depiction of dead (and perhaps also live) game. The 1825 exhibition saw watercolours by Hunt entitled *Rabbit, Pheasant, Woodcock* and *A Hare*; in 1826 his *Gamekeeper* (see cat. 11) was accompanied by paintings of *Dead Game* (twice), *Young Pigeon* and *Hen Pheasant*. In 1831, when a *Gallery of the Society of Painters in*

Watercolours began to be published, a portrayal of a keeper by Hunt was one of the three plates in the first instalment (fig. 4).[10] A letter from Hunt to a private correspondent, the editor, was accompanied by the print and its letterpress. In his characteristic style, with sparing use of punctuation, Hunt explained the genesis of the print:

> With respect to the drawing it is a portrait of a game keeper in the service of Charles Dixon Esqre Stansted Park the identical drawing was never exhibited but about five years since I had a larger drawing of the same figure with more game dog and other matter, painted for the above gentleman.[11]

Unlike the other known portraits of keepers by Hunt, this print shows the man in a Jacobean-style hall, enjoying some refreshment at the end of his labours. The letterpress gave his surname as Care, and explained that the drawing was made "some years ago", when he lived at Chicksands Priory, Bedfordshire, the seat of Sir George Osborne, Bart. The letterpress goes on to say that "an accurate representation is here given of the decorations of the interior of the hall" and that the original drawing is in the possession of "Mr Prior". A contemporary critic, reviewing the print, felt that there was "a strong feeling of individuality about [Mr Care], that tells as if it were his veritable self Care is represented in a very *anti-care-like* expression and attitude. Seated on a rude form, his right leg *carelessly* dangling over one corner of it, the left arm a-kimbo, the right hand holding a drinking horn"[12] The swaggering gamekeeper sitting on the hall table appears to be showing off his role as a superior servant close to his employer, while his placement in a somewhat spartan, baronial interior underlines the association of all forms of hunting with former times, catering to a growing nostalgia.

FIG. 4
Edward Smith
after William Henry Hunt
The Gamekeeper
Engraving

The letterpress to the print – presumably composed by Hunt himself – shows that he was aware of the topical relevance of his subject-matter:

> The Gamekeeper is, we believe, an appendage to the estate of the great landowner peculiar to this country; whether his occupation will become obsolete by the recent Game Bill, time alone can show.[13]

The Game Bill of 1831 required those who took or sold game to have a licence, and gamekeepers to be registered. It followed the Night Poaching Bill of 1828, which specified the penalties for armed poachers caught at night. There was, therefore, a great deal of discussion of the lives of gamekeepers, and the risks they faced in their daily lives, in the latter half of the 1820s. In 1821, H. Corbould exhibited a painting at the Royal Academy commemorating a fight in 1816 between gamekeepers and poachers which had resulted in one gamekeeper being killed and seven wounded.[14] William Mulready's painting *Interior of an English Cottage*

(fig. 5), exhibited at the Royal Academy in 1828, was originally titled *The Gamekeeper's Wife*, and showed the wife waiting anxiously for her husband to return.[15] Even after the Game Bill became the Game Reform Act in 1831, in the 1830s and early 1840s keepers were still being murdered at the rate of two per year.[16] Given this context, it is not surprising that Hunt's keepers look admirable, almost heroic. Gamekeepers were unpopular figures with the lower levels of rural society, but many visitors to the Water-colour Society exhibitions would have taken a much more positive view of their role. In 1832 a *Times* reviewer noted approvingly that the private view of the exhibition was "visited by a great number of persons of rank and fashion" and went on to name all the titled persons present, providing a list which included two Dukes, three Marquesses, six Countesses and four Lords. Such people were likely to be landowners with country estates. The same critic stated that "Mr Hunt has an abundance of drawings in that vigorous bold style which he has made his own".[17]

From 1829 Hunt exhibited many more studies of figures than in previous exhibitions: in that year no fewer than ten of his exhibits fell into this category. They included workshops on landed estates – an interior of a mill at Cassiobury and a blacksmith's shop at Stratfield Saye, home of the Duke of Wellington.[18] The latter painting attracted a favourable review from the critic of *The Literary Gazette*:

No. 59. *A Blacksmith's Shop at Strathfieldsay, Hampshire.* W. Hunt. As true as the camera-obscura, and much more spirited and painter-like. Mr. Hunt's eye for nice discrimination of hue and tone is perfect; and his execution is singularly sparkling and brilliant. In parts, the effect is absolutely phosphoric.[19]

There was a camera lucida in the sale of Hunt's effects after his death, so it is likely that he used this device when

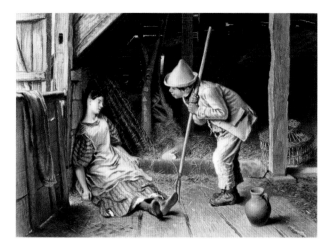

composing his interiors.[20] However, as the critic noted, he makes them much more than a dry record of a building. In this exhibition Hunt also showed country figures with more generic titles – *A Peasant Boy, Cow Boy, Children at a Cottage Door, Going to School*. By moving into this class of imagery Hunt was showing his affinity with artists like William Mulready and William Collins, who had been exhibiting somewhat sentimental paintings of cottage life, and especially cottage children, at the Royal Academy since the mid 1810s. In 1829 Hunt was clearly diversifying his output, and perhaps catering more for a middle-class audience, rather than the landowners who had been his patrons in the 1820s.

Hunt remained true to his subject-matter of estate servants and interiors in 1830, when he showed *A Gardener's Store Room* (see cat. 13) and *Interior of a Potter's Shed*. Once again, however, paintings of this type were outnumbered by more generic country figures, including several depictions of boys fishing, reflecting his habit of making regular summer visits to Hastings. As the current exhibition shows, he had a considerable interest in the occupation of the gardener, and especially in the production of exotic plants such as pineapples. As with the gamekeepers, there was a direct connection here between Hunt's figure paintings and the other category of his work, the still life. He was later to become famous for his depictions of fruit, especially of grapes with their soft bloom. It is evident that he also enjoyed portraying rustic interiors, making the most of the contrasting textures and colours of exposed brickwork, wooden beams and doors, and slate and brick floors. His technique was evolving in the early 1830s into a characteristic textured use of watercolour and bodycolour, with scratching out for highlights. More dishevelled figures and more battered interiors – the classic elements of the Picturesque – suited this new style. The *Woman peeling Turnips* (see cat. 17) is a particularly good example.

Hunt was also attracted by the more anecdotal, sentimental or comic aspects of rural genre painting in the 1830s – qualities that doubtless made his work more saleable. Around 1831 he met the young Swain brothers, who served as his models for several years.[21] It was in this year, too, that exhibits with the title of 'Peasant Girls' or 'A Peasant Girl' began to be staple items in his repertoire. He began to give his works narrative titles, such as *The Commencement* and *The Conclusion* (exhibited in 1834, and later renamed *The Attack* and *The Defeat*), which were paired paintings of a boy in a smock eating an enormous pie. In 1844 enough of this kind of work existed for him to produce a book of coloured lithographs entitled *Hunt's Comic Sketches*.[22] This volume included *The Gleaner – A Village Beauty* (see cat. 17) and *Cymon and Iphigenia – or Love at First Sight* (fig. 6). A modern audience can easily recognise the humour in *Cymon and Iphigenia*, even without

its mock-heroic title, but it is more difficult for us to see why *The Gleaner* is funny. She is, after all, supposed to be a child labourer, even if her large bonnet does make her look slightly ridiculous. *Cymon and Iphigenia* reuses the barn interior and sleeping girl of *Slumber* (cat. 19). This was also made the subject of a print, with the title *A Sleeping Nymph* – presumably this, too, was meant to be humorous.

When, in 1879, the critic John Ruskin wrote notes about Hunt's paintings for an exhibition at the Fine Art Society, he divided his figure studies into three classes. He was particularly critical of the comic works, which he designated Class Three:

Country life with some expression of its degradation, either by gluttony, cowardice, or rudeness. The drawings of this class are usually very clever, and apt to be very popular; but they are, on the whole, dishonourable to the artist.[23]

Ruskin appears to have been thinking here of the kind of drawing lithographed for *Hunt's Comic Sketches*. These are the drawings that have suffered most from changing tastes, for their humour is generally of the condescending kind that finds entertainment in the misfortunes of the less privileged, or mocks their aspirations to beauty.

Hunt also produced watercolours of rustic figures that evoke a comforting sentiment, with titles like 'Prayer', 'Devotion', 'Piety' or 'Saying Grace'.[24] Paintings of the rural poor going to church, or reading the Bible (see cat. 14), were particularly popular in this period, when concern was expressed at the tendency of the working class to cease attending church when they moved from villages to towns. It was reassuring, therefore, to see evidence that traditional piety – and the moral values, including contentment, that were presumed to be an integral part of Christian faith

– were still being practised in the countryside.[25] Ruskin placed such works in his Class Two:

Country life, with endeavour to add interest to it by passing sentiment. The drawings belonging to this class are almost always over-finished, and liable to many faults.[26]

Another admirer of Hunt's figure studies was F.G. Stephens, who knew the artist in his later years, and wrote a long article on him in 1865. He conceded that Hunt's later work was now more popular, but praised his watercolours of the 1825–40 period for "their subtle and comparatively sober tints, their exquisite rendering of light and shade, their chiaroscuro and their tender toning".[27] He mentioned two portraits of gardeners in this article, and noted also:

At Cassiobury is … a water-colour sketch by Hunt, a copy from an oil-picture, which is now in the possession of the Dowager Countess of Essex; this is a portrait of a gardener who is still living …. Mr Leaf, of Park Hill, Streatham, has an early picture, 'A Gentleman's Gardener'.[28]

Stephens evidently preferred Hunt's earlier, more serious and dignified country figures to his *Comic Sketches*. He wrote that "the sentiment which frequently inspired the pictures of Hunt's early manhood was more potent than the man himself would in later life admit", but later on "the pathetic tinge of thought seemed fading from his mind, and humour took much of its place".[29]

Despite his misgivings over the comic and sentimental aspects of Hunt's figure studies, John Ruskin was generally enthusiastic about his work. Like Stephens, Ruskin preferred the serious to the comic, including in his Class One category:

Drawings illustrative of rural life in its vivacity and purity, without the slightest endeavour at idealisation, and still less with any wish either to caricature or deplore its imperfections. All the drawings belonging to this class are virtually faultless, and most of them are very beautiful.[30]

This exhibition focuses on the kind of drawings that Stephens and Ruskin would have admired, in which Hunt gives us an appealing vision of a rural society of dignified individuals. They look justifiably proud of their expertise in the raising of pineapples or pigs, their knowledge of guns and game, or the ordered neatness of their workshops.

Hunt was working at a time when country life was changing rapidly, and when too much emphasis on controversial topics could deter potential patrons. Unlike Landseer (see fig. 2), or later Victorian social-realist painters such as Hubert von Herkomer, he appears to have avoided subjects that would be uncomfortable to his viewers and remind them too forcefully of the very real social problems of the countryside during a period of political ferment. As Ruskin recognised, Hunt was skilful at catering for his buyers' tastes. When working mainly for the landed aristocracy in the 1820s, he presented reassuring images of estate servants and other country people who 'knew their place' within an apparently stable social hierarchy. By the 1830s he found a thriving market for comic or sentimental figure scenes among middle-class buyers. To a modern audience Hunt's sympathetic representations of country people hold a fascination both for their aesthetic qualities and for the questions they raise about the relationship between the rich and the poor, and the changing social and agricultural world in which they lived and worked. The dispassionate approach Hunt appears to have adopted in those years, and in what many now regard as his best work, has a combination of the aesthetic and the scientific that is characteristic of much British art around that time. With his detailed attention to nature and everyday objects, as Ruskin observed, "It is hardly necessary to point out the earnestness or humility in the works of William Hunt; but it may be so to suggest the high value they possess as records of rural life, and still life".[31]

1 William Wordsworth, *Lyrical Ballads*, Preface.

2 On this group, see Christiana Payne, '"Calculated to gratify the patriot": Rustic Figure Studies in Early-Nineteenth-Century Britain', in Michael Rosenthal, Scott Wilcox and Christiana Payne, eds., *Prospects for the Nation: Recent Essays in British Landscape, 1750–1880*, New Haven and London: Yale University Press, 1996, pp. 61–78.

3 Ibid., p. 74. Pyne's comment was made in *The Somerset House Gazette*, vol. 2, no. 30 (1 May 1824), p. 46.

4 For a list of his exhibited works, see John Witt, *William Henry Hunt (1790–1864): Life and Work, with a Catalogue*, London: Barrie and Jenkins, 1982.

5 Giles Waterfield and Anne French, with Matthew Craske, *Below Stairs, 400 years of Servants' Portraits*, exh. cat. National Portrait Gallery, London, 2004, pp. 160–72.

6 Ibid., p. 57.

7 Witt 1982, p. 175.

8 *The Somerset House Gazette*, vol. 2, no. 35 (5 June 1824), p. 130.

9 Witt 1982, p. 241. On the second day's sale, Tuesday 17 May 1864, no. 304 was *The Miller at Cashiobury* (sic); no. 293, *A Gamekeeper*, was between two pictures of "Cashiobury", so it

10 See *Arnold's Magazine of the Fine Arts, and Journal of Literature and Science* (1832), pp. 68–71, for a review of this publication.

11 Letter to Mr George, East Beach St, Hastings, dated 17 November 1831 (private collection).

12 *Arnold's Magazine of the Fine Arts* (1832), p. 70.

13 Letterpress to print (private collection).

14 Royal Academy, 1821, no. 435. The full title of the painting was *Cat Grove, with portraits of game-keepers in the service of Col. Berkeley, engaged with a desperate gang of sixteen poachers, on the night of the 18th Jan. 1816, when one of the keepers' party was killed, and seven wounded.*

15 Marcia Pointon, *Mulready*, exh. cat., Victoria and Albert Museum, London, 1986, p. 167.

16 P.B. Munsche, *Gamekeepers and Poachers: The English Game Laws 1671–1831*, Cambridge: Cambridge University Press, 1981, p. 157.

17 *The Times*, issue 14845 (Monday, 7 May 1832), p. 5.

18 OWCS nos. 52, *An Interior of a Mill, Cashiobury, Herts*; 59, *A Blacksmith's Shop at Strathfieldsay, Hampshire*; 275, *A Blacksmith's Shop at Strathfieldsay.*

19 *The Literary Gazette: A Weekly Journal of Literature, Science, and the Fine Arts*, no. 642 (9 May 1829), p. 307.

20 Witt 1982, p. 243 (item no. 374); see also cat. 17.

21 Ibid., pp. 44–45.

22 Ibid., pp. 44–46.

23 Ibid., p. 251.

24 OWCS, 1831, no. 86, *Prayer*; 1833, no. 392, *Devotion*; 1837, no. 105, *Piety*; 1842, no. 167, *Saying Grace.*

25 Christiana Payne, *Rustic Simplicity: Scenes of Cottage Life in Nineteenth-Century British Art*, exh. cat., Djanogly Art Gallery, Nottingham; London: Lund Humphries, 1998, pp. 19–20 and cat. nos. 1, 5, 8, 42.

26 Ruskin's notes on Hunt for his exhibition of Prout and Hunt at the Fine Art Society, 1879–80, with a list of the works exhibited, reprinted in Witt 1982, pp. 244–56.

27 F.G. Stephens, 'William Henry Hunt, Water-colour painter', *Fraser's Magazine* (1865), p. 532.

28 Ibid., pp. 529, 534.

29 Ibid., p. 534.

30 Ruskin's notes on Hunt, in Witt 1982, p. 250.

31 John Ruskin, *Pre-Raphaelitism* 361, from *Venetian Notebooks*, in E.T. Cook and Alexander Wedderburn (eds.), *The Works of John Ruskin*, 'Library edition, 39 vols, 1903–12, vol. 12, p. 361.

NOTE ON THE CATALOGUE

The JW number given in the following entries refers to John Witt's catalogue raisonné of 1982.

Catalogue

1

Farmer in a Barn, c. 1820

Watercolour over traces of graphite, 274 × 182 mm
Birmingham Museums and Art Gallery
James Leslie Wright Bequest, 1953
JW 271

NOTES

1 A small watercolour sketch, *A Stable Boy*, dated 1815, is held at the Courtauld Gallery (D.1982.JW.7).
2 Howitt 1840, 2nd edition, p. 100.
3 Possibly diluted brown ink used as wash, as in *The Gardener* (cat. 9) and other early drawings.

According to his cataloguer and collector, John Witt, this is one of the first of Hunt's watercolour studies of a standing rural figure in an interior setting. Earlier drawings, sketched on the spot in and around the country town of Bushey, more often show people at work outside (fig. 7).[1] Static subjects such as this required more concentrated study and Hunt's disability forced him to draw from a low seated position, unusually behind his sitter in this instance.

William Howitt, a contemporary writer on rural life, noted "that amongst farmers are to be found men of all ranks and grades".[2] At the beginning of the century, farmers for the most part farmed land that was not their own but rented from the landowner. Distinct barriers existed between those who worked with their hands and those who did not. The neat attire and nonchalant pose of this so-called farmer give him an air of authority that suggest he is a man of social standing. Yet, whether owner occupier, tenant farmer or farm bailiff, possibly connected with the Earl of Essex's Cassiobury Park, his status is unknown.

Yellow and brown shades,[3] commonly used by the artist at this period, are heightened with touches of blue for sky, red on the face and hands, and an eye-catching rust-brown for the woollen socks. Textural details of wood, wattle, thatch and straw are applied with loose brushstrokes. A shaft of light streaming through an opening forms shadows on door and walls – a recurring motif in Hunt's cottage and barn interiors, later to become his most favoured settings.

FIG. 7
William Henry Hunt
Saw Mill, Bushey
Reed pen, brown ink and
watercolour, 257 × 358 mm
The Huntington Library, Art Collection,
and Botanical Gardens, San Marino

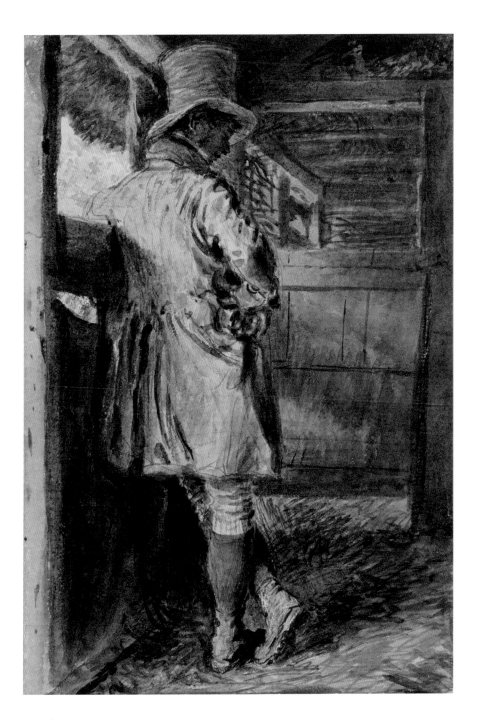

2

The Miller in his Mill, 1824

Pen and brown ink and watercolour over graphite,
387 × 303 mm
Signed in pen and brown ink on sack at left: *W.H.*
Birmingham Museums and Art Gallery
James Richardson Holliday Bequest, 1927
JW 272

NOTES

1 *Portrait of an Old Man*, JW 473, Lady Lever Art Gallery, Port Sunlight.
2 Jones 1981, no. 123, p. 60.
3 The author is grateful to Martin Watts, Historic Building Research and Recording Traditional Milling and Millwrighting Specialist for this information.
4 Unpublished manuscript, Royal Society of Watercolours Archive, J55, in Fenwick and Smith 1997, 'William Henry Hunt', pp. 184–88.

The Miller and *The Gamekeeper* (see cat. 5) were the first of Hunt's drawings of country people to be exhibited at the Old Water-Colour Society (OWCS). His quivering reed pen line and monochrome colouring is attributable to the copying of pen-and-ink drawings by Canaletto at Thomas Monro's 'academy'. Similarities in the facial features and dress of the miller with an old man depicted in another Hunt drawing,[1] thought to be a miller and farmer of Bramley in Hampshire with the surname Holloway, have led to the suggestion that they are both the same man.[2] Holloway was a relative of Hunt's mother who rented a house in the village where he spent much of his childhood and in later life owned a house. He became Holloway's son-in-law, having married his daughter Sarah in 1830.

Mills played an important role in nineteenth-century rural life. Improvements in farming techniques enabled farmers to produce more wheat that in turn was ground to make flour in local mills such as the one depicted here. Its internal arrangements, with two pairs of millstones encased on a table behind the miller, indicate that it is a small pre-industrial watermill.[3] Despite advances in mass-production techniques in some industries, up to the mid century craftsmen such as millers, carpenters and blacksmiths managed to retain a key position in village life and enjoy the benefit of running a small independent business. This well-to-do miller-cum-farmer appears at ease in his role as an agricultural businessman.

Hunt only ever worked from life. The accurate precision with which he has drawn this scene typifies his method of close observation, as a description of his sketching with William Mulready and John Linnell indicates: "[He] sat down before any common objects as cottage garden rails or an old post and endeavour [sic] to minutely imitate ... and copying closely as much earnestness [sic] as an old broom or waterbutt or a three legged stool".[4] He was fascinated with buildings, implements and tools, as is evident from the detailed attention given to such objects as millstones, sacks, ropes, besom broom, cogs, wheels and shafts. The prominent ladder, cutting the corner of the image, shows a bold use of props to enliven the set – a testament to skills acquired in his theatrical work.

3

A Maltster resting, c. 1820–25

Black chalk, brush and ink wash, watercolour and
bodycolour, with some scraping out, over graphite,
395 × 340 mm
Private collection
JW 373

NOTES

1 Pyne 1804, beside pl. 12.
2 The present work was formerly titled *Interior of a barn*: see
Witt 1982, no. 373, p. 177. See *Interior of a Barn with a Figure* in
Jones 1981, no. 134, p. 66.

As the watercolourist, illustrator and publisher W.H. Pyne
remarked of his drawing of brewers for *The Costumes of Great Britain*,
"The British porter, beer, and ales, have the reputation of excelling
the malt-liquors of every country: and are esteemed to be both
wholesome and nutritious".[1] Malting was important to the rural
economy in the nineteenth century as it was the most profitable use
for barley. The incomes of small farmers were frequently eked out
by additional employment, often as maltsters or millers. Many small
malthouses existed in and around country towns and villages to malt
their own produce, some of which went back to the farms to be used
in brewing beer for the farmer and his men. The malting process was
lengthy. The grain was first soaked in a steeping pit or cistern for a
day or more to germinate. It was then spread out on the growing floor
for up to three weeks, regularly turned over to aerate, then dried in a
kiln. When ready, it was sieved to remove the shoots and stored for a
few months to develop flavour.

The independent maltster was a person of some importance in the
community.[2] As with the miller (cat. 2), there is no hint of 'honest
toil' or idealisation in this portrayal. Both men are depicted in their
work place at ease rather than in action. The maltster's self-assured
appearance suggests he was the owner of the business, or perhaps a
valued employee of the man seen in the background. Alternatively, he
may have been employed by the Earl of Essex, since the drawing was
made during the period that Hunt worked for him at Cassiobury Park
in Hertfordshire, a county known for its abundant supplies of barley.

As in many of his studies of country people in interior settings,
Hunt has drawn attention to a few strategically placed objects within
the scene, notably a wooden shovel for turning over the grain, a
besom broom for sweeping the floor, and two flagons – glistening
stoneware being a favourite motif of the artist, whose immaculate
still-life renderings of pots were greatly admired. With its muted
colouring, contrasts of light and dark, and softly focused distance,
such a scene also anticipates photographic portraits of country
people, notably those of William Henry Fox Talbot, David Octavius
Hill and David Adamson (see also cat. 20).

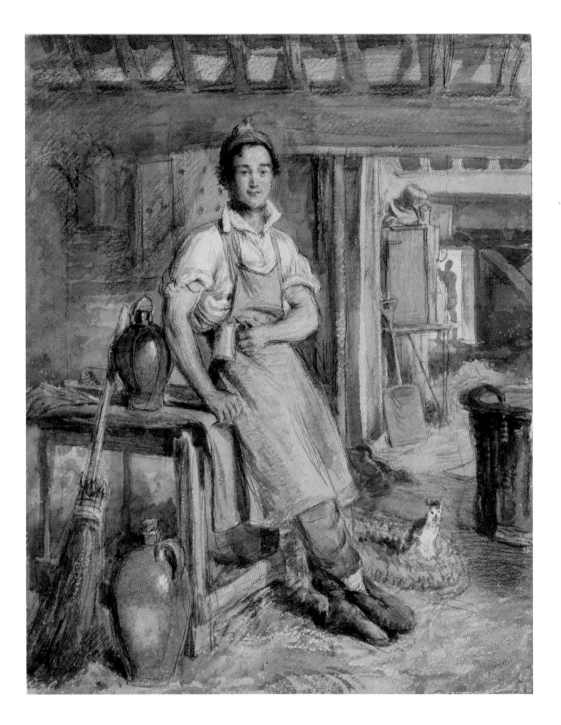

4

Kitchen Interior with Young Man sitting by the Fire, c. 1820–25

Brush and brown ink, and watercolour with some scraping out over graphite, 195 × 273 mm
Private collection
JW 372

NOTES

1 Cobbett [1830] 1853, vol. 1, p. 18; vol. 2, p. 266.
2 Hunt, *An Irish Labourer*, 1827, JW 402, The Huntington Library, Art Collections, and Botanical Gardens, San Marino.
3 For further discussion on woodcutters' work, see cat. 18.
4 'Address to Plenty', 1820, from *Poems Descriptive of Rural Life and Scenery*, in Tibble 1935, p. 47.

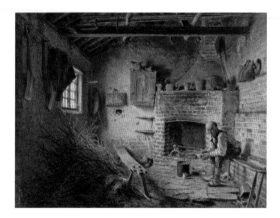

FIG. 8
William Henry Hunt
The Woodcutter's Breakfast, c. 1832–34
Watercolour over graphite
The Metropolitan Museum of Art,
New York

In 1830 radical reformist William Cobbett railed at the living conditions of agricultural labourers in small, unsanitary cottages, describing them as "miserable sheds" and "wretched hovels Enter them and look at their chairs and stools The floor of brick, or the bare ground"[1] This dilapidated kitchen-cum workplace is far from comfortable, with sparse furniture, smoked-stained bricks and broken flagstones. Commissions in the early 1820s from the Earl of Essex and the Duke of Devonshire to paint their great houses at Cassiobury and Chatsworth may have acted as the catalyst for Hunt's preoccupation with the humbler dwellings with which he was more familiar. One of his earliest watercolours of a cottage interior, this drawing shows to perfection his enjoyment of hand-crafted objects and materials, be they a carved wooden bench, earthenware pot, black iron kettle, straw basket or besom broom.

Hunt was particular with the titles of his work, and this one is most probably not his own. An inscription on the verso reads: *Paddy at Home*. At the time, Paddy was a derogatory nickname for an Irishman, many of whom took work in England as agricultural labourers, exemplified by his drawing *An Irish Labourer*.[2] The man seen here wears typical labourer's clothes, including top hat. Hunt later refashioned the setting for a more orderly and finely wrought scene, *The Wood Cutter's Breakfast* (fig. 8), also known as *The Faggot-Gatherer's Meal*. The similarity of objects in these drawings, particularly the stack of wood on the left, suggests that both labourers shared the same occupation.[3] Words of the poet John Clare aptly describe the scene, impressing the significance of a warm hearth in the lives of ill paid country people:[4]

> Place me in some corner, where,
> Lolling in an elbow chair,
> Happy, blest to my desire,
> I may find a rousing fire;
> While in chimney-corner nigh,
> Coal, or wood, a fresh supply,
> Ready stands for laying on,
> Soon as t'other's burnt and gone.

5

The Gamekeeper, c. 1824–25

Pen and brown ink, brush and ink wash and
watercolour over graphite on an extended sheet
of paper, 349 × 237 mm
Signed lower right: *W.HUNT*
Private collection
JW 377

NOTES

1 Quoted in Avery 1990, p. 100.
2 *Somerset House Gazette*, 1824, vol. 2, p. 46.
3 The author is grateful to firearms expert David Frost
 for this information.
4 Witt 1982, no. 377, p. 177, lists the drawing as OWCS, 1824,
 no. 62, or 1825, no. 133 or 341, and in 'Works Exhibited at the
 Society of Painters in Water-Colours, 1814–1864', p. 219;
 as listed by Stephens [1865] 1935.
5 From J.J. Jenkins, transcripts of Hunt's letters and Mss
 notes, Royal Society of Watercolours Archive, J55, in
 Fenwick and Smith 1997, 'William Henry Hunt', pp. 184–88.
6 Ibid.
7 William Henry Hunt to Philip Broome, 21 February 1862,
 ibid.

"Honour the Squire, the landowners, the farmers, the Magistrates, the guardians of the Poor, the bailiff, and the Gamekeeper, that thy days may be long spared to enjoy such blessings." This Fifth Parody of the Ten Commandments expresses the widely felt resentment for the 'high and mighty' by less privileged rural inhabitants in Hunt's time.[1] At the other end of the social scale, paintings of gamekeepers were greatly popular, largely owing to the patronage of wealthy owners of big estates and the widespread interest in field sport among visitors to exhibitions in the early years of the nineteenth century. Between 1824 and 1828 Hunt exhibited no less than five watercolours of gamekeepers at the Old Water-Colour Society, of which the first was shown together with *The Miller* (cat. 2). It received a glowing review in the *Somerset House Gazette*: "Another happy effect of water-colours particularly engaged our attention, although by an artist whose modest talent has remained in obscurity. This is not a landscape, but a coloured study of a gamekeeper, in the service of the Earl of Essex. It is a very original and masterly example of richness and effect."[2] The description could well refer to the present drawing. The bold figure of a man with red waistcoat and flintlock gun,[3] silhouetted against a light blue and beige backdrop, would no doubt have stood out from more conventional types of figure drawing in the 1824 exhibition.[4]

Hunt was averse to imitating earlier artists' styles, once remarking on another work: "I like that because it is not like a drawing master's drawing".[5] By his own account he could only ever draw "from nature".[6] In his older age, in praise of the drawing of an aspiring young student, he told the boy's father he was "laying a good foundation by his severe studying of the figure as a means of teaching him to see and draw correctly colour, and light and dark, [but] he must get a taste and knowledge by looking at nature, as well as looking at pictures".[7] Hunt's acute observation is evident in the life-like rendering of the sitter's stubbled chin and in the textures and trimmings of his working clothes, such as the line of gaiter buttons, a shiny leather cartridge-bag strap and powder flask below it, a loosely tied cravat and stiff white collar, all no doubt painted in the studio, as was Hunt's regular practice.

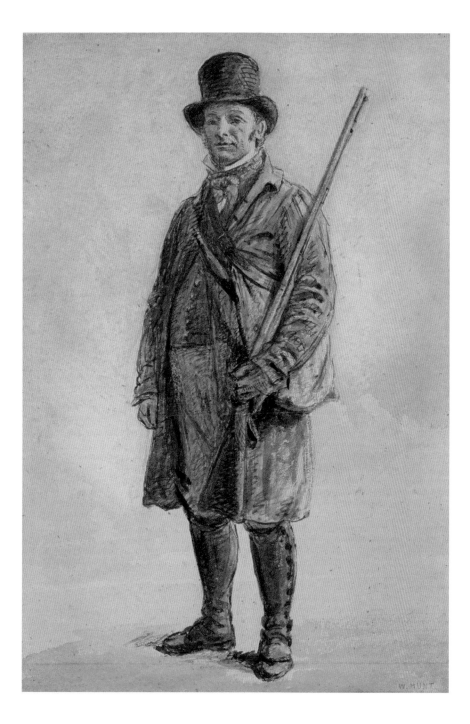

6

The Poacher, 1825

Watercolour over graphite, 317 × 242 mm
Williamson Art Gallery and Museum, Birkenhead
Gift of John McKay, 1930
JW 268

NOTES

1 See Witt 1982, no. 268, p. 168, exh. OWCS, 1825, no. 139, as *A Poacher*. Witt gives 1857 as the exhibition date of the second drawing (no. 228).
2 One possibly *The Gamekeeper* (cat. 5); see there footnote 2.
3 H.J. Little in the 'Royal' Journal essay of 1878, quoted in Fussell 1940, p. 118.
4 Ruskin, 'Notes on Samuel Prout and William Hunt'; quoted in Witt 1982, p. 245.
5 More, 'Black Giles the Poacher', in More 1801, vol. V, pp. 416–17.
6 Jones 1979, p. 929.
7 See p. 16 above in this volume.

The Poacher is one of only two drawings of the subject known to have been exhibited by the artist.[1] It was shown at the Old Water-Colour Society in 1825 together with two of Hunt's gamekeeper drawings[2] and one of the Cassiobury Park gardener (cat. 10). Most likely the man portrayed was local to the estate, though it is doubtful whether he was an actual poacher, as Hunt tended to use models. He is dressed in a typical labourer's oufit, similar to one described in 1878 – "trousers and coat of corduroy or fustian, and breeches and gaiters of stout leather, a loose cotton neckerchief round his neck and stout heavy boots. He must have had some kind of hat",[3] in this case probably made of felt, with a red flower attached. The flat painted backdrop, a reminder of Hunt's work as a theatrical scene-painter, indicates that the figure was modelled indoors. For John Ruskin, a keen admirer of Hunt's work, these early watercolours, reflecting John Varley's teaching methods, "depended for their peculiar charm on the most open and simple management of transparent colour".[4]

Shooting in the early nineteenth century was exclusive, as it was restricted by law to those of landed wealth with shooting rights not restricted to their own land. Prior to the Night Poaching Bill of 1828, a person caught breaking the law was penalised by seven years' transportation. Despite such harsh punishment, poaching remained a serious problem as it was a traditional way of life for many, and few labourers regarded wild animals or birds as private property. While Victorian worthies such as Hannah More considered poaching to be "a regular apprenticeship to bolder crimes",[5] "to the labouring community the poacher was not a criminal, and indeed might be regarded as a respectable member of the village community".[6] For all the respect given to gamekeepers by the landowning fraternity, whose sporting privileges they were supposed to protect, they were unpopular figures with the lower levels of rural society, as Christiana Payne observes,[7] and there were running wars between gamekeepers and poachers, with casualties on both sides. Hunt, who was known to enjoy the company of low-life characters, nonetheless depicts a benign-looking figure, expressing, perhaps, a respect for village, rather than professional, poachers, whose 'bag' would have provided a cottager's family with a good meal.

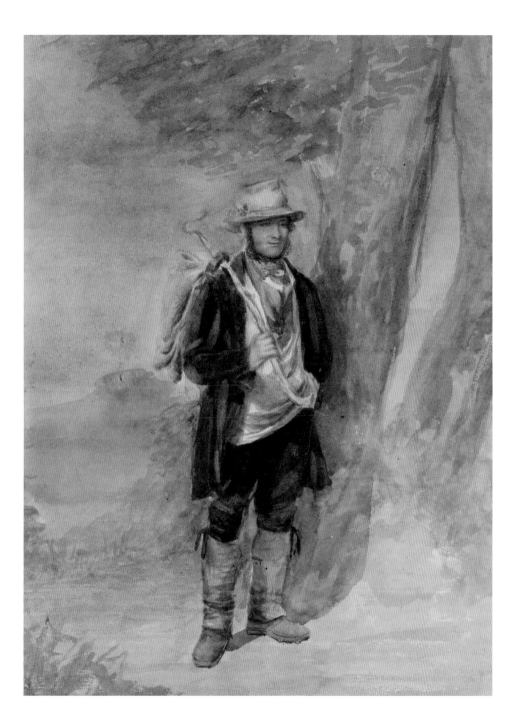

7

The Maid and the Gamekeeper,
c. 1825

Pen and brown and black inks, brush and ink wash,
watercolour and bodycolour over graphite on an
extended sheet of paper, 321 × 304 mm
Signed at lower left: *W.HUNT*
Private collection

NOTES

1 It is not known whether the title is Hunt's own.
2 I am grateful to David S.D. Jones, gamekeeping historian,
 for this information (see also cat. 11, note 1).
3 Grey 1934, pp. 69–70.
4. Young 1813, p. 222.

The informal and intimate nature of this drawing, portraying two
people, sets it apart from other figure scenes in the exhibition.[1]
In smart attire, the dapper young man is more likely to be a country
sportsman than a gamekeeper. According to David Jones, "keepers
of the period invariably wore a dark green coat and waistcoat,
(occasionally black or dark blue), while sportsmen usually wore
lighter clothing, often fawn, mustard or similar".[2] Rather than face the
viewer, as do most of Hunt's sitters, the couple are portrayed in the
manner of a conversation piece – an informal group much favoured
by eighteenth-century figure painters, notably Thomas Gainsborough.
Leaning casually on a low brick wall, the man watches intently as
a maid plaits straw. With frilled mob cab, puffed-sleeved dress and
laced ankle boots, the woman bears a strong resemblance, both in
clothing and stance, to the kitchen maid seen in Hunt's watercolour
of the Cassiobury Park kitchen (fig. 11) while, in facial features and
dress, her companion resembles the model for *The Gardener* (cat. 9),
wearing a similar striped waistcoat, red neckerchief and light coloured
trousers. Quite possibly both were members of the estate staff whom
the artist used as models for this anecdotal scene.

The craft of straw plaiting for hats and decorative items was
widely practised in nineteenth-century rural England, particularly
in Hertfordshire, the county of the Cassiobury estate. Payment
for the work was a vital source of income, as indicated in 1870 by
a local farmer and writer, Edwin Grey, who described the industry
as "excellent for cottage homes: firstly, it was of a clean nature and
then again the housewife could, when wanting to go on with other
house-work, put aside her plaiting, resuming it again at any time.
She could also do the work sitting in the garden or whilst standing
by the cottage door enjoying a chat or gossip with her neighbours."[3]
Such words describe precisely the maid's activity – one that was
complained of by farmers "as doing mischief for it makes the poor
saucy and no servants can be procured or any field work done where
this manufacture establishes itself".[4] Her mask-like face and delicately
painted hands, and the additional strip of paper along the top edge of
the sheet, suggest that Hunt may have been reworking the drawing for
exhibition although no records are known of its sale.

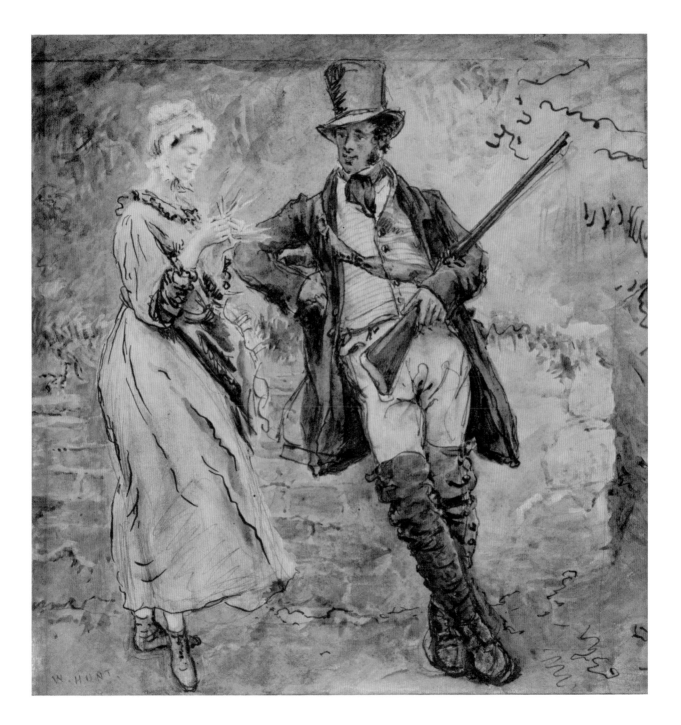

8

The Vegetable Man, c. 1825

Watercolour and pen and brown ink over graphite,
311 × 220 mm
Victoria and Albert Museum, London
Captain Charles B. Lyon by family descent;
gift to Victoria and Albert Museum 1961
JW 521

NOTES

1 Whereabouts unknown. Oil painting was unusual for Hunt;
 he was working almost exclusively in watercolour by this time.
 See cat. 9.
2 Stephens [1865] 1935. The watercolour was sold at Christie's,
 21 November 2007, lot 17, withdrawn from sale.
3 Roget 1891, vol. 1, p. 393.
4 Stephens [1865] 1935.

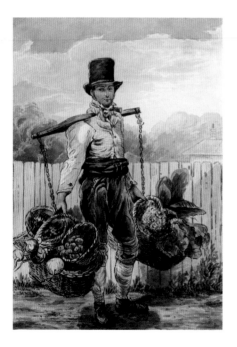

This watercolour study is one of three known preliminary works made in preparation for an oil painting of a gardener at Cassiobury Park.[1] According to the critic F.G. Stephens, a watercolour sketch of the painting was in the possession of the Dowager Countess of Essex in 1865, a year after Hunt's death (fig. 9).[2] Being the least finished, this study, traditionally known as *The Vegetable Man*, is most probably the first. Freely handled reed-pen lines typify it as an early work, as does Hunt's delicate use of translucent washes, a method learnt from his influential drawing teacher John Varley, whose advice to look to nature is evident from the artist's attention to detail. Assorted vegetables and items of clothing such as the wide cummerbund, striped waistcoat and neckerchief are painted in carefully modulated tones of yellow, blue, green and brown, with touches of red. Only the face is more finely worked, as was Hunt's regular practice.

While he made sketches at Cassiobury for the Earl of Essex, Hunt "used to be trundled on a sort of barrow with a hood over it, which was drawn by a man or a donkey".[3] Whether modelled outside or within the confines of the artist's studio, the man is somewhat stiffly posed. It is uncertain if Hunt ever had much practice in drawing from life in the Royal Academy school. As Stephens noted, "Excellent as was his drawing of figures in drapery, it is deficient in that precision and firmness of treatment which characterize the accomplished draughtsman from the naked form".[4]

FIG. 9
William Henry Hunt
The Gardener
Watercolour copy of oil painting
(formerly in the possession of the
6th Earl of Essex), whereabouts
unknown

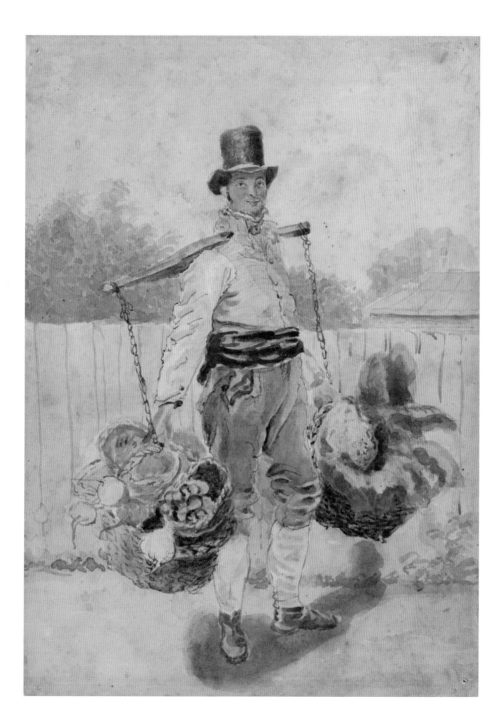

9

The Gardener, c. 1825

Pen and brown ink, brush and ink wash, and watercolour
with some scraping out over graphite, 382 × 267 mm
Signed lower right: *W. HUNT*
The Courtauld Gallery, London: Samuel Courtauld
Trust, D.1967.WS.55
William Spooner Bequest, 1967
JW 324

NOTES

1 Witt 1982, no. 324, p. 173, suggests it could be *The Gardener*
 exhibited at the OWCS in 1825, but *The Head Gardener*
 (cat. 10) is a more likely contender.
2 I am grateful to Christopher Hasler, descendant of Thomas
 Hainge, for the image and further information.
3 Attfield family tree (http://www.johh-attfield.com/paf_tree/
 attfield_current/fam1048.html)
4 Davies 1987, pp. 82–83. I am grateful to Jennifer Davies for
 her invaluable advice. See also Loudon 1822, pp. 1040–41.

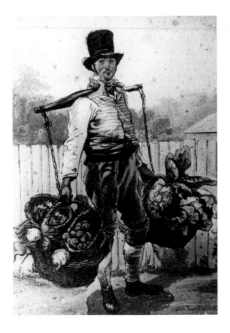

FIG. 10
William Henry Hunt
Study for *The Gardener*
Watercolour
Private collection, USA

Formerly entitled *The Vegetable Seller*, this representation of a
gardener bears a similarity with the eighteenth-century tradesman
type portrayed in *The Cries of London* series of Francis Wheatley and
Paul Sandby, with whose drawings in Thomas Monro's collection
Hunt was familiar. *Pentimenti* or alterations to the left leg, chain link
and hat indicate that this was intended as preparatory work, although
the artist's signature suggests that he considered it a saleable
drawing.[1] (Note the marks of 'flooded out' ink behind the head,
where he has attempted to remove his corrections.) A further study,
with the leg as redrawn here, exists (fig. 10).[2] On a photographic
reproduction of it, an inscription reads: "Original drawing by Hunt
made at Cassobury [sic] Park for George, Earl of Essex for a picture
in oil. It was given to Thos Hainge of whom it is a portrait who was
and still is a gardener at Cassobury [sic] Park and to whom it now
belongs. Cassobury Park [sic] May 24 1873." This is unlikely, since
at the time of this drawing Hainge was in his twenties, while records
of his employment on the estate show him first as a labourer in
1838, then as a garden labourer in 1861, and as a gardener in 1871.[3]
As the dates reveal, it took many years of apprenticeship to rise to the
position of gardener. It was the responsibility of the head gardeners
and their staff to supply the owners of large estates with fresh fruit
and vegetables from the kitchen garden; the foreman was responsible
for making up the produce which would be carried up to the mansion,
generally in yoked baskets by a garden apprentice or journeyman.[4]
Similarities in facial features and clothing – striped waistcoat, light
coloured trousers and red neckerchief – with those of the man
depicted in *The Maid and the Gamekeeper* (cat. 7) would suggest
that he was one of Hunt's regular models.

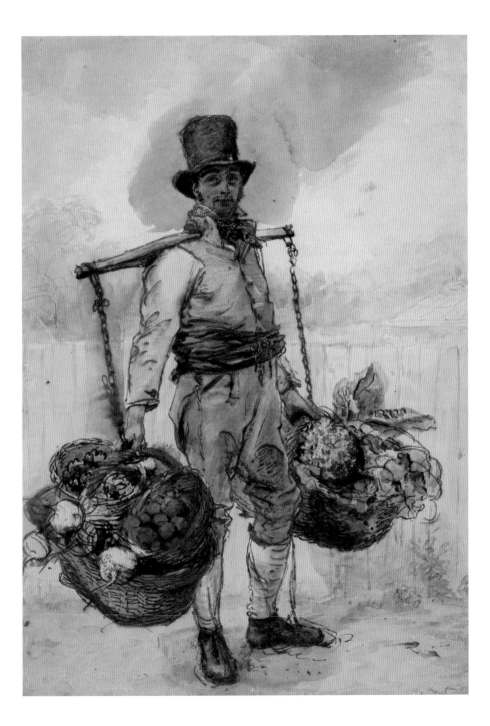

10

The Head Gardener, c. 1825

Pen and brown ink, brush and ink wash and
watercolour and bodycolour, over graphite,
with traces of gum and some scraping out on
an extended sheet of paper, 288 × 347 mm
Signed lower right: *W.HUNT*
The Courtauld Gallery, London: Samuel Courtauld
Trust, D.2011.XX.2
Dorothy Scharf, 1998; Lowell Libson Ltd; acquired 2011
in memory of William Clarke (1943–2010), with the
generous support of Elizabeth Clarke, the V&A Purchase
Grant Fund, the Worshipful Company of Mercers and
the Samuel Courtauld Trust

NOTES

1 See *A Selection of British Pictures*, exh. cat., Lowell Libson
 Ltd., Summer 2006, unpaginated.

This fine 'exhibition' watercolour is most probably *The Gardener*, shown at the Old Water-Colour Society in 1825 together with *The Poacher* (cat. 6) and possibly *The Gamekeeper* (cat. 5). Designed to impress, the style is that of an oil painting, using brown ink wash with touches of gum for glazed effects, raised white bodycolour for texture, noticeably for the white spots on the melon in hand, and muted washes of blue, green and orange watercolour, overdrawn throughout with vigorous penstrokes. The complex composition, part figure study, part still life, boxed into a narrow stage-like space, is unusual in Hunt's oeuvre. Surrounded by vegetables and exotic fruits, a top-hatted man stands beside a basket of freshly packed produce, proudly displaying a melon, a much prized dessert fruit at the time. Supposedly the Earl of Essex's head gardener,[1] a highly respected position in the hierarchy of estate servants, he was responsible for supplying the household all year round with the widest possible variety of flowers and culinary produce, ensuring

FIG. 11
William Henry Hunt
The Kitchen at Cassiobury Park
Pen and ink and watercolour,
394 × 324 mm
Property of the Maas Gallery, London

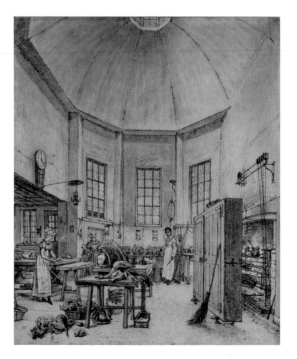

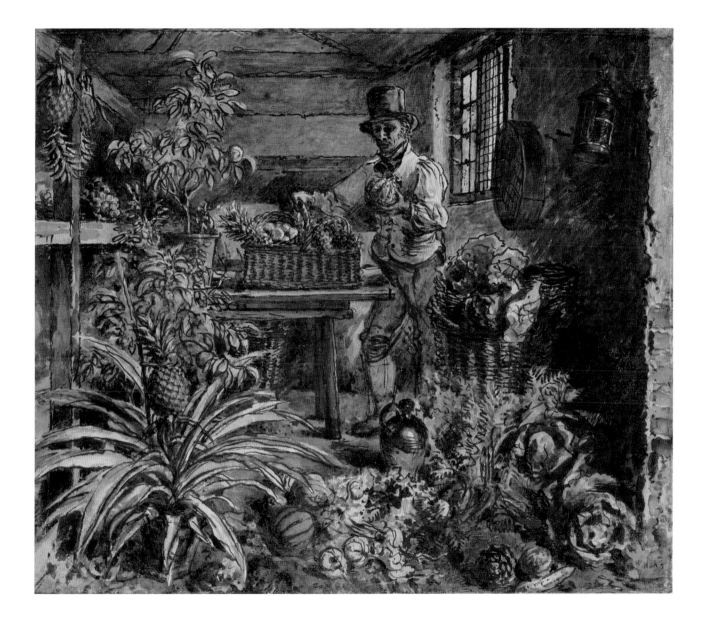

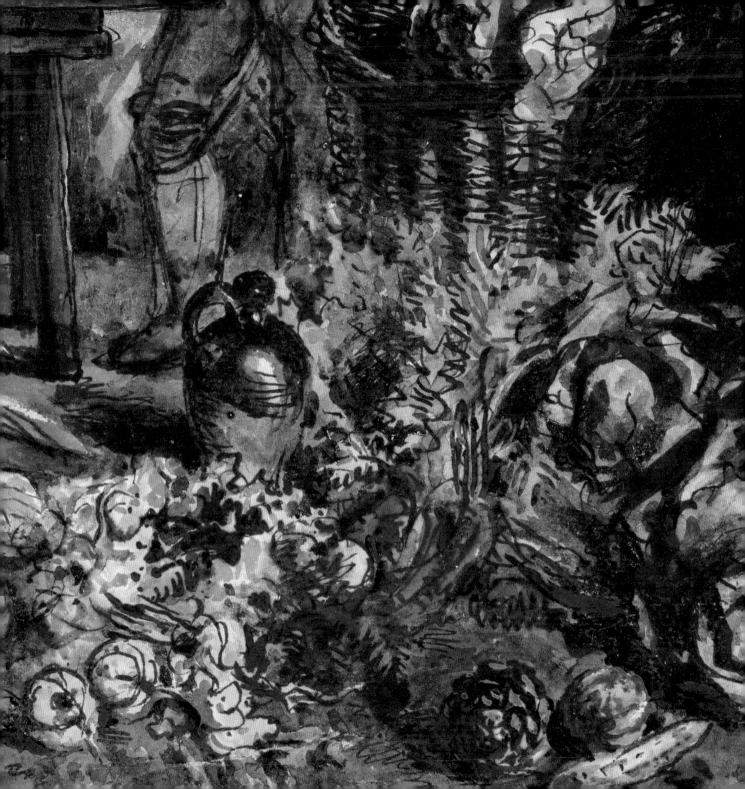

2 James Anderson (1797–1842) later became Superintendent of the Botanic Garden, Sydney. See Rabbits and Kerenza Priestley 2014, p. 70. See also Anderson's account of J.C. Loudon's visit to Cassiobury Park in October 1825: "As an item of consumption, the gardener, Mr Anderson, informed us that he had sent in last year ten thousand heads of celery There are some very good pines here": *The Gardener's Magazine* (1836), pp. 285, 287.

that they were delivered to the kitchen in good condition (fig. 11). The choice of fruits, including pineapples, melons, grapes, peaches and nectarines grown at great expense under glass or in hot beds, and prized vegetables such as celery, cucumber and artichokes, would no doubt have impressed Cassiobury Park guests. The head gardener at the time was James Anderson, a well-respected collector of plants in Africa and South America.[2] Hunt's work could thus be read both as a testament to his skills and to the wealth and status of his employer.

11

The Gamekeeper, 1826

Pen and brown ink and watercolour over traces
of graphite, 430 × 300 mm
Private collection
William Ward (of Richmond); The Hon. Charles
Duncan, 1892, and family by descent; Lowell Libson
Ltd, 2010

NOTES

1 I am grateful for this information to David S.D. Jones,
 author of *Gamekeeping: An Illustrated History*, and to
 Charles Nodder of the National Gamekeepers Association
 (email 19 March 2017).
2 Jefferies [1878] 1948, pp. 12, 13.
3 The Courtauld Gallery holds two Hunt drawings of similar
 subjects: *Dead Pheasant*, D.1982.JW.11, and *Dead Game*,
 D.1982.JW.23, both dated *c.* 1825–26, and also *Shelf with
 Two Pots and Two Hanging Ducks*, D.1952.RW.2196, *c.* 1828.
4 Quilter 1892, facing p. 180. See Libson's account in *A
 Selection of British Pictures*, exh. cat., Lowell Libson Ltd,
 Summer 2006, unpaginated.

This striking work is one of the finest of Hunt's studies of country people, among whom gamekeepers ranked high in the hierarchy of estate workers. Like head gardeners, they occupied a secure position in the employment of wealthy landowners, whose sporting privileges they were required to protect. With proud bearing, this "quintessential 1820s gamekeeper"[1] lives up to his reputation in the way described by Victorian country writer, Richard Jefferies: "He meets your eye full and unshirkingly, yet without insolence; not as the labourers do …. Perfectly civil to everyone, and with a willing manner towards his master and his master's guests …. So he really takes the lead …. It is not difficult to see how in this way a man whose position is lowly may in an indirect way exercise a powerful influence upon a large estate."[2]

Hunt's working of the figure and background, largely in brown ink washes, is not unlike his treatment of *The Gardener* (cat. 9). An inscription on the backing board reads: "Drawn from Nature by Wm Hunt", meaning drawn from life. The watercolour is signed and dated 1826, during which time Hunt was working for two major landowners, the Earl of Essex at Cassiobury Park in Hertfordshire and Charles Dixon of Stansted Park in West Sussex. In the same year he exhibited eight works at the Old Water-Colour Society, six of which had connections with shooting, including *Dead Game*,[3] *Young Pigeon* and *Hen Pheasant*, and a drawing entitled *A Gamekeeper in the Service of Charles Dixon, Esq*. This last may be the present drawing, or it might be the original of a watercolour of a gamekeeper belonging to Harry Quilter and reproduced in his *Preferences in Art* of 1892 (see fig. 12).[4] Dixon purchased his estate the same year that the present drawing is dated, and, as a newly landed gentleman, he could have commissioned

FIG. 12
William Henry Hunt
The Gamekeeper
Pen and ink and
watercolour,
as reproduced in Harry
Quilter, *Preferences in Art,
Life and Literature*, 1892

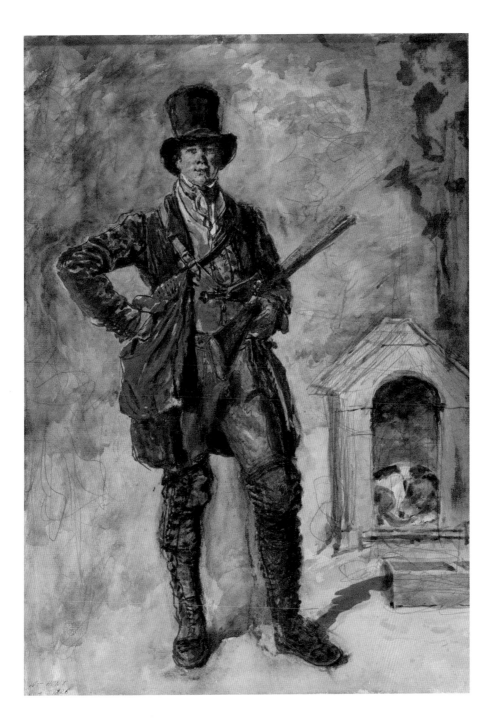

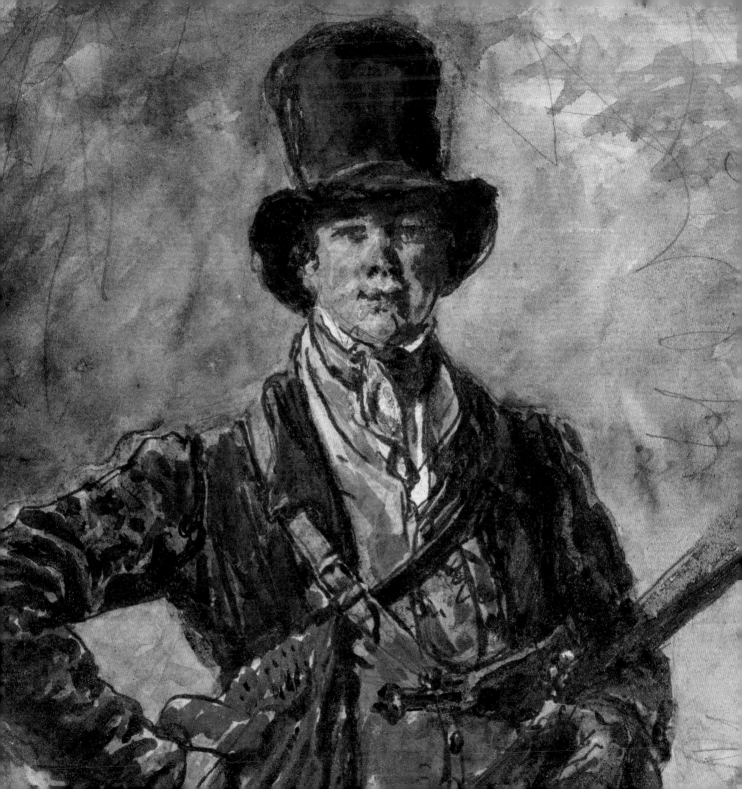

5 See the mentions of Dixon on pp. 14–15 above in this volume.

6 I am grateful for this observation to David Frost of The National Gamekeepers Association (see also note 1). A similar face appears also in Hunt's gun-hold drawing (cat. 12).

7 For a further representation of a gamekeeper, see fig. 15 in this volume.

this portrait to demonstrate his sporting credentials to the county establishment.[5] The fact that a similar face appears both in Quilter's watercolour and in the present drawing, and that the guns in both are held at a dangerous angle,[6] suggests that Hunt used a model rather than an experienced shot. Quilter's comment on his drawing in any case applies to the image shown here: "Hunt has got to the heart of the subject, not rested content with the outer man. And in this Gamekeeper we have a type of the class, as well as a representation of the subject."[7]

12

Study for a Gun Hold with a Sketch of a Man's Head, c. 1826

Graphite, pen and brown ink, brush and ink wash,
watercolour and body colour, 330 × 340 mm
Private collection

NOTES

1 See cat. 11, note 7.
2 I am grateful both to David Frost and to Charles Nodder for their advice and assistance (see further cat. 11, notes 1 and 7).
3 R. Jefferies, *The Gamekeeper at Home*, Oxford, 1948 [1848], p. 5.

Born and brought up in London, Hunt had no first-hand experience of game shooting – the privilege of the landed gentry – before his employment by the Earl of Essex and Duke of Devonshire in the 1820s. Commissioned to paint estate staff, be they butler, cook, maid, farmer, gardener or gamekeeper, he closely observed the dress and tools of their trade, in some instances gaining inside knowledge of their work in the process. Here he focuses on a gun hold, possibly modelled by the man sketched below, whose face bears a similarity to that seen in *The Gamekeeper* (cat. 11). The sheet is a rare example of Hunt's working method, showing three different processes – broad brushstrokes outlining the edges of the jacket, an individual pencil sketch, and a coloured detail, built up with washes of brown ink. The sketches, however, have no match in Hunt's gamekeeper images, since he tended to use drawing as a form of exercise, rather than as preparation for painting. The hold shown is a common and safe way to carry a gun.[1] According to firearms expert David Frost, it is a double flintlock, probably a 12-bore. "The hammers appear to be at half cock. Double guns were not so common at the time and may indicate he was better off or better provided for than some keepers."[2]

In *The Gamekeeper at Home* (1878) Richard Jefferies aptly described the affection his subject felt for his gun: "... no other ever fitted the shoulder so well, or came to the 'present' position. So accustomed is he to its balance and 'hang' in the hand that he never thinks of aiming; he simply looks at the object, still or moving, throws the gun up from the hollow of his arm, and instantly pulls the trigger, staying not a second to glance along the barrel. It has become almost a portion of his body, answering like a limb to the volition of will without the intervention of reflection. The hammer chased and elegantly shaped – perfectly matching Being an artist in his way, he takes a pride in the shine and polish of his master's guns."[3] These words strike true with Hunt, who delighted in the look and feel of tools and implements and their 'shine' and 'polish' in his drawings.

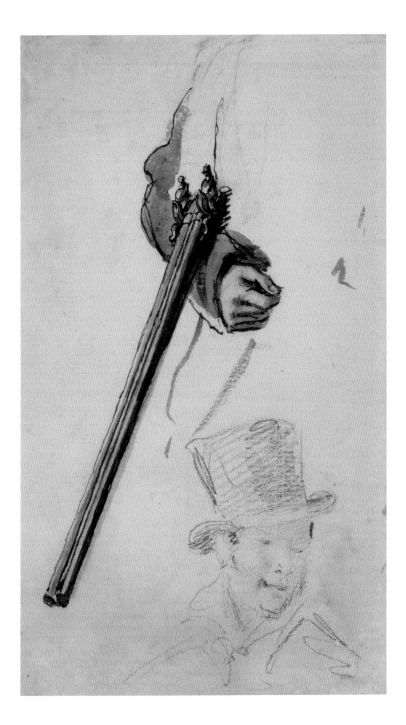

13

The Gardener, c. 1830

Pen and brown ink, and watercolour and
bodycolour over graphite, 135 × 116 mm
Private collection
(on loan to The Ashmolean Museum, Oxford)

NOTES

1 Loudon 1822, p. 1233. Grateful thanks to Sarah Kerenza
 Priestley, curator of Watford Museum, for access to the
 Cassiobury Archives.
2 Havell 1823, pp. 110ff.
3 Puckler-Muskau 1832, pp. 197–98.
4 J. Robson, *Journal of Horticulture*, 1872, vol. 22, p. 455,
 quoted in Morgan and Richards 1990, p. 110.
5 Witt 1982, no. 112, p. 220.
6 For the question of identify, see cat. 9.
7 Ruskin [1857] 1903–12, vol. 15, p. 71.
8 Jones 1981, p. 50, notes that his handling of paint
 resembles scene painting techniques, "especially in
 brushwork that can only be seen to represent something
 at a distance". In an exchange over James Orrock's
 watercolour of a pineapple, Hunt cited theoretical reasons
 for his choice of colours, describing "that grey-green mass
 of colour" as "of great value in the picture ... in contrastive
 harmony with the rich body of yellow in the pineapple
 itself, and unites this third mass, these deep purple-black
 Hamburgh grapes, comprising a trio of massed colour in
 the design": Webber 1903, p. 164.

The gardens at Cassiobury Park were famed from the seventeenth century when the 5th Earl of Essex inherited the estate in 1799. Like his father "a great encourager of gardening",[1] he made many improvements, employing Humphry Repton (1752–1818) to reconfigure the landscape and design a new orangery. In 1823, Robert Havell observed: "Besides almost every species of deciduous and exotic trees, plants, and shrubs that will live in the English climate, several hot-houses and green-houses are appropriated to rear and preserve the more delicate and tender shrubs and fruits".[2] Prince Herman Puckler-Muskau, too, admired the kitchen garden and "the endless rows of rich hot-houses and forcing-beds",[3] in which exotic vegetables and fruit, notably pineapples, peaches, nectarines, melons and grapes were grown and overwintered. Introduced from Barbados into England in 1657, pineapples were considered amongst the most delicious of all fruits. The pinnacle of achievement for the Victorian gardener was "a constant supply of first rate pines",[4] while their appearance at the dining table was an opportunity for one-upmanship for his employer.

This watercolour is possibly *A Gardener's Store Room*,[5] exhibited in 1830, by which time Hunt's technique was becoming more varied and his colours brighter. With basket in hand, the so-called gardener[6] poses as if for a studio portrait, beside carefully arranged hot-house fruit tiering down to the floor on staged shelving. The artist has zoomed in on the figure, not fully in the picture and lit from a window similar to that seen in *The Head Gardener* (cat. 10). Colouring and treatment of fruits and leaves are glaringly expressive. Grapes in the gardener's basket, for instance, consist of rudimentary circles of grey-green, blue and purplish red, intermixed with bodycolour to effect "a dusty kind of bloom".[7] For the pineapple, a criss-cross mesh of bright red lines is painted with the point of a brush over a layer of translucent red wash, with shades of grey-green and blue, and stabs of white in the interstices; elsewhere white bodycolour is liberally applied, notably to highlight large and decorative pineapple leaves.[8] The blues of the sitter's cummerbund and neckerchief make a compositional link with the colourful fruits around him. For William Collingwood it was to Hunt's "realising the value of complementary

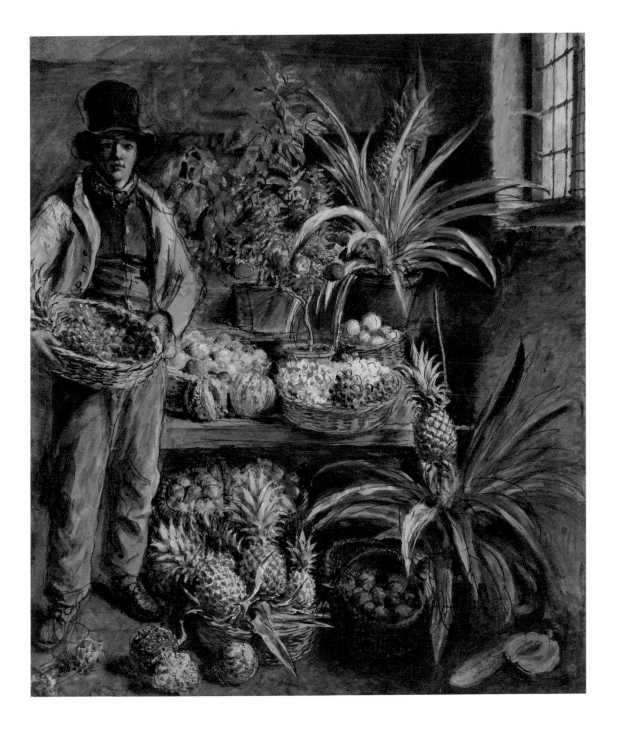

9 Collingwood 1898, p. 505.
10 Ruskin [1857] 1903–12, vol. 15, pp. 223–24.
11 Jones 1981, p. 36.

colour his pictures largely owe their power".[9] While John Ruskin, an admirer of his gradated colour techniques, advised his students to "practice the production of mixed tints by interlaced touches of the pure colours out of which they are formed, and use the process at the parts of your sketches where you wish to get rich and luscious effects. Study the works of William Hunt, of the Old Watercolour Society, in this respect."[10] As one modern-day observer has noted, "the way Hunt constructed his colours can be parallelled in the work of Turner and Delacroix, despite differences of medium and subject-matter".[11]

In a life that straddled the invention of photography, Hunt's images of country people such as this both anticipate and resemble photographic studio portraits of the 1840s and beyond (see further cat. nos. 3 and 20).

14

Study of a Countryman reading, c. 1830–36

Watercolour over graphite, 410 × 320 mm
Signed lower right: *W.HUNT*
Private collection

NOTES

1 See, for example, Hunt's *An Old Man reading the Bible* (JW 481), Lady Lever Art Gallery, Port Sunlight Village.
2 See also Payne 1998, pp. 19–20.
3 See for example, *Rustic Devotion*, *c*. 1840, Harris Museum and Art Gallery, Preston, and note 7.
4 JW 478, Lady Lever Art Gallery, Port Sunlight Village. See Ruskin's notes on his 'Exhibition of Hunt and Prout' at the Fine Arts Society, 1879–80, in Witt 1982, no. 171, p. 254, and, for his three 'Classes' for Hunt's works, above in this volume, pp. 17–18.
5 Avery 1990, p. 98.
6 On the basis of an inscription on an exhibition label on the verso of the drawing, noted by John Robertson: Witt 1982, no. 86, p. 221.
7 JW 436, Whitworth Art Gallery, Manchester. With reference to this drawing Jones observes (no. 120, p. 59) that some of Hunt's religious titles suggest antipathy to Catholicism.
8 Witt 1982, no. 166, p. 254.

Images of church-going rural poor at prayer or reading the Bible were popular subjects in mid-nineteenth-century England.[1] As Christiana Payne has noted, they provided reassuring evidence that piety and moral values were still being practised in the countryside.[2] Between 1833 and 1836 Hunt exhibited no less than nine works entitled *Devotion*, most showing rustic characters.[3] John Ruskin showered praise on *The Blessing* of around 1840, and classified it as Class One in his system of appraisal of Hunt's works.[4] In Victorian times prodigious amounts of religious literature, aimed at cottagers, was issued by such publishers as the Religious Tract Society. Thousands of homilies pointed out "the follies of ambition and the blessings of contentment", urging their readers to be thrifty, to abjure smoking and drinking, and do their duty in the name of God.[5]

Hunt shows a countryman, seated in a reverential position on a low 'kneeler' chair, reading from a book with the word *PRAY* printed in capitals on the opening page. It is thought that this could be the drawing shown at the Old Water-Colour Society in 1831 with the title *Prayer*.[6] If so, it was the first religious work Hunt exhibited. It was accompanied by the first verse (an expanded definition of prayer) from a well-known hymn written by the Scottish-born poet James Montgomery (1771-1854) beginning: "Prayer is the Soul's sincere desire / Unutter'd or express'd / The motion of a hidden fire / That trembles in the breast".

Ruskin put Hunt's religious works such as this into his Class Two category: "Country life, with endeavour to add interest to it by passing sentiment", as exemplified by *Praying Boy* (otherwise known as *Devotion*).[7] This he considered to be "overfinished, as its companion, no 165" (*Prayer*) … "an endeavour at doing what he did not understand …. His mode of work was entirely unfitted for full life-size."[8] At the time, the price of a watercolour was largely determined by its size, most probably Hunt's reason for the large scale.

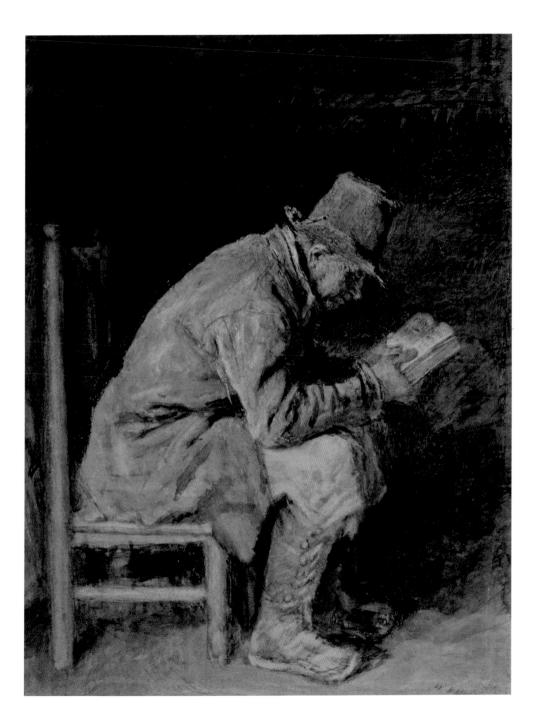

15

Girl with a Sheaf of Corn (The Gleaner), c. 1832

Brush and brown ink, watercolour and bodycolour
over graphite with extensive scraping out, 279 × 200 mm
Private collection
The Rev. E. Coleridge; Gilbert W. Moss, sold Christie's,
20 March 1900 (as *The Young Gleaner*), lot 135;
JW 383

NOTES

1 On Hunt's predecessors, and on gleaners, see p. 7 in this
 volume.
2 *Hunt's Comic Sketches, drawn on stone by Thomas Fairland*
 from original drawings exhibited in the Water-Colour Society,
 Henry Graves & Co., London, 1844.
3 Grey 1934, pp. 69–70.
4 Allan Cunningham (ed.), *The Anniversary*, London, 1829, p. 58.
5 Quoted in Witt 1982, no. 166, p. 251.
6 Fitzwilliam Museum, Cambridge; whereabouts unknown.

With his shrewd business sense and newly found interest in drawing children in the early 1830s, Hunt began to produce a more anecdotal type of rural figure, as popularised earlier in the century by Robert Hills, Joshua Cristall and Thomas Uwins (see fig. 1), among others.[1] This is one of twelve of his drawings of children to be reproduced in lithographic form in Thomas Fairland's *Hunt's Comic Sketches*, in which it is entitled *The Gleaner – A Village Beauty*.[2] Apart from her boots, the girl's costume hardly matches that of Victorian gleaners, most of whom "wore their oldest clothes (it being said that any old thing would do to wear on this job), the better clothes being thus saved so much wear and tear".[3] Posed before a Gainsborough-like wooded landscape, in patterned blouse and large hand-stitched sunbonnet setting off her pretty face, the sitter is most likely a local child in the guise of a gleaner. With the subtitle *A Village Beauty*, Hunt's image could be read as a humorous take on engraved 'Beauties' in popular gift books, notably *The Anniversary*, in which the contemporary poet Allan Cunningham praised William Beechey's oil painting *The Little Gleaner* (fig. 13) – a fanciful representation of a virtuous child – describing it as "fair nature by poet fancy drest".[4] Appealing, though not overly sentimental in its sweetness, the subject falls into Ruskin's Class Two category of his most admired Hunt works, namely "Country life, with endeavour to add interest by passing sentiment".[5] Exhibited at the Old Water-Colour Society in 1832, it was sufficiently popular for him to make two identical copies.[6]

This drawing is a prime example of Hunt's famously inventive use of scraping out – the method by which the whites of the blouse and the stalks of the corn are formed here (see also the detail on page 8 in this volume).

FIG. 13
Edward Francis Finden
after Sir William Beechey
The Little Gleaner, 1806-1857
Engraving and etching
103 × 93 mm
British Museum, London

16

The Stonebreaker, 1833

Watercolour and bodycolour with some scraping
out over graphite, 358 × 252 mm
Signed lower left: *W.HUNT 1833*
Royal Watercolour Society
Ralph Bernal; sold Christie's, 23 April 1853, lot 342;
R.W. Parsons Bequest, 1979
JW 497

NOTES

1 *The Gardener's Magazine*, February 1833, p. 514.
2 See Christiana Payne in this volume, p. 12.
3 Miller 1847, pp. 138–39.
4 Quilter 1892, p. 184.

Stonebreakers were employed to lay or repair the new roads that transformed communications during the nineteenth century (fig. 14). The backbreaking work was accomplished "simply by employment of the superfluous labour in the different parishes ... by giving all able-bodied men, who apply for parish relief, work at a fair rate of wages".[1] This watercolour was made a year before the Poor Law Amendment Act of 1834 that formalised the workhouse system for paupers and discouraged other forms of relief for the poor.[2] Some years later an observer noted: "We pass on to another, employed by the parish to break stones on the road. He works by the piece, and in winter earns six or seven shillings a-week – in summer, eight or nine If the farmer's labourer, with constant employment, can but just make ends 'meet and tie', how does he manage, whose income is so much smaller Would you feel astonished to find this man turned poacher?"[3]

Amongst Hunt's portrayals of country people this image is the most poignant. Taking a break from his labours, an old man, with battered straw hat and torn jacket, leans on a long-handled mallet beside some newly crushed stones. The expression is care-worn yet his posture is upright and bearing dignified. Unlike the subsequent paintings of stonebreakers by Henry Wallis and John Brett, Hunt's image conveys no overt moral message. Disabled and without high social standing, he himself surely empathised with the less privileged members of the rural community. Here, rather than stress the harshness of the elderly man's labours, he portrays him with dignity and respect, emphasising his wrinkled face and wistful gaze – a study of old age. Harry Quilter's view on Hunt's treatment of rural figures is most apt here: "[T]hough it reflects the English conventional feeling in such matters, it does so with absolute unconsciousness, and shows that the painter himself is entirely sincere in his representation. All that he saw in the rustic is here, quite untouched by affectations."[4]

FIG. 14
After George Walker
Stone-Breakers on the Road, aquatint,
pl. VIII in George Walker, *The Costumes of Yorkshire*, 1814
The British Library, London

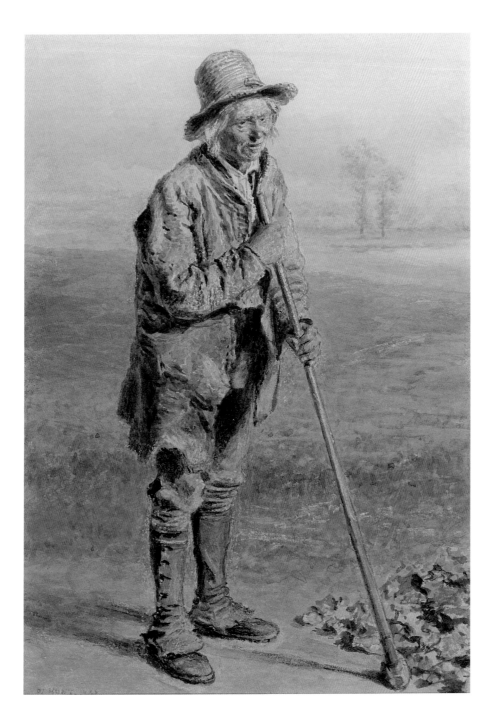

17

The Kitchen Maid (Woman peeling Turnips), c. 1833

Watercolour and bodycolour with some scraping
out, over graphite, 450 × 464 mm
Signed on sack rear right: *W.HUNT*
Nottingham Castle Museum
Fine Art Society, 1957
JW 460

NOTES

1 A fine example is David Teniers's *Interior of a Kitchen with an Old Woman peeling Turnips* in the British Royal Collection.
2 See, for example, *The Maid and the Magpie* (The Higgins, Bedford) or *Woman peeling Apples* (Laing Art Gallery, Newcastle). A Hunt watercolour, *The Kitchen of an Old Farm House* (private collection) of around the same date as the present work, shows an older woman peeling turnips who is possibly Hunt's wife Sarah's mother.
3 A landscape by Philips Wouwerman showing a women peeling turnips was displayed in Cassiobury House: see *A Catalogue of the Contents of Cassiobury Park, Watford, Herts,* Knight, Frank & Rutley, Sale of Pictures, 15 June 1922, cat. 803, p. 57.
4 Dickens [1867] 1911.
5 See Christiana Payne in this volume, p. 16, and Jones 1981, p. 35 and no. 75, p. 39. For Hunt and photography see further cat. 20.
7 Monkhouse 1885–1900, p. 282.

A woman preparing fruit or vegetables was a common subject in seventeenth-century Dutch and Flemish genre scenes.[1] Similar themes occur in other drawings by Hunt,[2] who would doubtless have been acquainted with such works through prints and drawings seen at Dr Monro's house and the great painting collections of Chatsworth and Cassiobury.[3] Turnips played a significant role in British agricultural history. Having been introduced from the Netherlands in the eighteenth century, their efficient use as a rotational crop enabled an abundant and cheap food supply for both households and farm animals throughout the country. Charles Dickens's description of a woman "sitting, in a great coarse apron that quite smothered her ... beginning to peel the turnips for the broth for dinner",[4] could well apply to Hunt's sitter, his wife Sarah, the 'kitchen maid' of the title, posing here most probably in their farmhouse on her father's property in Bramley, Hampshire.

A combination of the artist's painterly skills and close observation, with the possible aid of a camera lucida,[5] account for the extraordinarily life-like textures of materials and objects in which he delighted – the uneven brick floor, earthenware pots, a hanging net-bag and hessian turnip-sack (incorporating his signature), wood and leather bellows, a copper chestnut-roaster, and roughly hewn wood throughout. To achieve his effect, Hunt used an amalgam of techniques, from layers of watercolour, drily applied in places on the walls and ceiling, to thick white bodycolour, on the glinting knife blade for example, and fine stippling for flesh and the shaded contours of pots. With judicious use of scraping out to white paper, he emphasised patches of reflected light, notably on the door bolt and barrel lid, dress and apron, and the tips of turnip leaves. In the eyes of poet and critic Cosmo Monkhouse, "No one, perhaps, has ever realised so fully the beauty of common objects seen in sunlight at a short distance".[7]

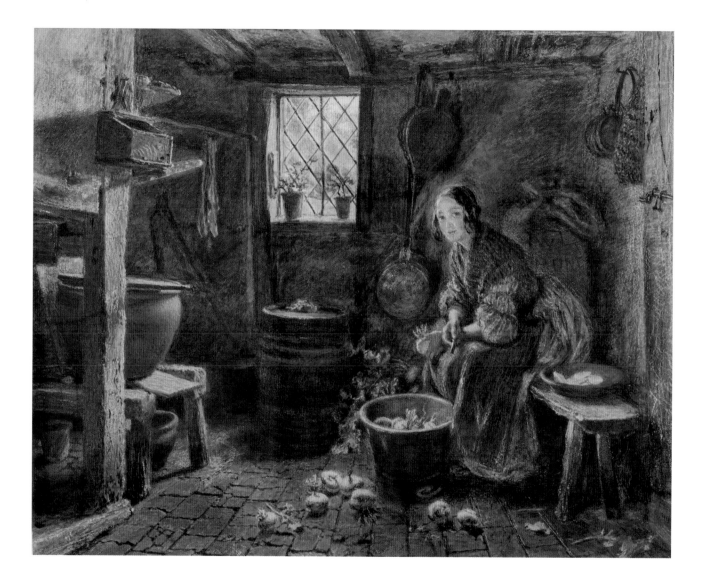

18

The Broom Gatherer, c. 1835

Watercolour over graphite, 300 × 196 mm
Signed lower left: *W.H. HUNT*
Harris Museum and Art Gallery, Preston
Richard Newsham Bequest, 1883
JW 483

NOTES

1 Cobbett [1830] 1853, vol. 1, p. 73.
2 Possibly Hunt's brother-in-law, Charles Steedman.

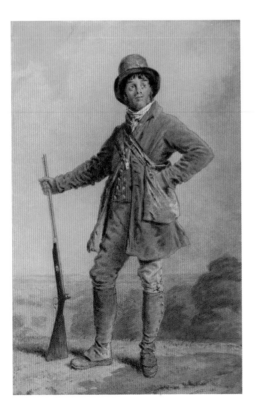

During the nineteenth century huge numbers of labourers and agricultural workers were employed in the seasonal coppice and woodland trades. As William Cobbett observed, "… woodland and forest labourers are best off in the main. The coppices give them pleasant, and profitable work, in winter."[1] Yet, following the Enclosure Acts that allowed the common lands of a parish to be divided amongst private owners, poor country people were less able to source peat, brushwood and rough timber to fire their hearths. Many, therefore, welcomed the chance to gather wood for payment in cash or in kind. An integral part of the job was making the 'faggot' or bundle. A 'long' faggot consisted of lengthy sticks, while a 'short' or 'brush' faggot, as seen here, was made from brushwood, including gorse (more commonly known as broom), native to heath- and moorland.

Wood collecting was a favoured subject of eighteenth-century artists, notably Gainsborough. In a chalk sketch for his celebrated (now lost) painting *The Woodman* a man carries faggots on his back. The copying of such 'rustic' figures – and also W.H. Pyne's well-known illustrated manual, *Etchings of Rustic Figures: for the Embellishment of Landscape* (1815), which included 'Wood Gatherers' – may have encouraged Hunt to focus on individual rural characters such as this. The man depicted here appears to be one of Hunt's regular models.[2] His face is remarkably similar to a portrait of gamekeeper dated 1835 (fig. 15), no doubt commissioned by the subject's employer. Compared with the polished, superior gamekeeper, however, this humble labourer, whose livelihood was very different from that of farmers, gamekeepers and gardeners, appears pensive and dishevelled. Rather than serving as a portrait, Hunt's drawing appears to represent a 'type' of worker, typical of his class.

FIG. 15
William Henry Hunt
The Gamekeeper, 1834
Watercolor, with pen, in brown ink, graphite, and gouache on beige, laid paper, 379 × 244 mm
Yale Center for British Art, New Haven, Connecticut

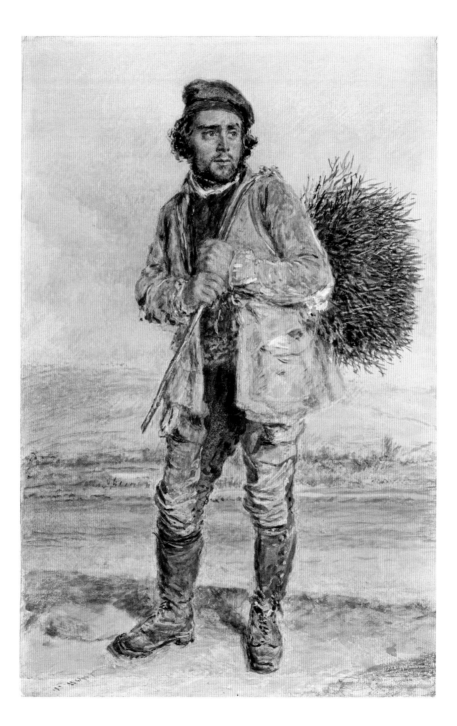

19

Slumber, c. 1835–40

Watercolour and bodycolour with some scraping out,
352 × 437 mm
Signed lower right: *W.HUNT*
Birmingham Museums and Art Gallery
Cotman Galleries; John Feeney Bequest Fund, 1928
JW 274

NOTES

1 From J.J. Jenkins, transcripts of Hunt's letters and
 Mss notes, Royal Society of Watercolours Archive, J55, in
 Fenwick and Smith 1997, 'William Henry Hunt', pp. 184–88.
2 Witt 1982, pp. 219–28.
3 Witt 1982, no. 282, p. 223.
4 Thomas Fairland after William Henry Hunt, published
 by Graves & Warmsley, London (British Museum,
 inv. no. 1868,0612.947).
5 Samuel Bellin after William Henry Hunt, published by the
 Fine Art Society, London, 8 August 1885. A watercolour of
 1837 entitled *Cymon and Iphigenia* (JW311), with similar
 models, was exhibited as *Girl in a Wood-house* at the OWCS
 the same year (Towneley Hall Art Gallery and Museum,
 Burnley); a larger version (JW501), exhibited in 1838, is
 listed in the Captain R. Sheepshanks collection.
6 *Hunt's Comic Sketches, drawn on stone by Thomas Fairland
 from original drawings exhibited in the Water-Colour Society,*
 Henry Graves & Co., London, 1844.
7 Possibly that exhibited as *A Farmer's Boy* in 1842.
8 For further discussion see Jones 1981, no. 116, p. 56.

"I always see everything in pictures," Hunt was purported to have said.[1] *Slumber* is a supreme example of his approach to a new subject. Although the title does not appear on the Old Water-Colour Society exhibition list,[2] it is possibly *Sleeping Girl*, shown in 1838.[3] Hunt regularly portrayed children reclining or reading, perhaps in this way keeping his sitters still. Although better known for his comic child images at this time, he could be remarkably delicate and sympathetic in his portrayals of young people, as in this scene of a girl asleep in a hay loft, a pair of socks dropped on the floor alongside wool and a spool of thread and a darning mushroom. A lithograph of the drawing, entitled *A Sleeping Nymph*, was published in 1843 (fig. 16).[4] One of many prints that contributed to Hunt's fame at this time, it was possibly an innocent variation of a painting by John Hoppner entitled *Sleeping Nymph and Cupid* reproduced as a mezzotint in 1824. A lithograph entitled *Cymon and Iphigenia* (or *Love at First Sight*; see fig. 6),[5] another classical theme in modern dress, was published in 1844 in *Hunt's Comic Sketches*.[6] The print was based on a watercolour known as *The Farmer's Lad*,[7] which, in turn, appears to have been derived from *Slumber*, since the setting is the same, as are the boy and the girl in a striped dress, both Hunt's regular models.[8] The comment by Jones on *Cymon and Iphigenia*, that "the grand seen in terms of the

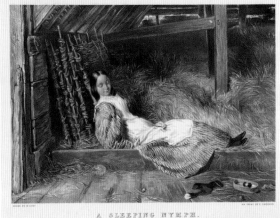

A SLEEPING NYMPH.

FIG. 16
Thomas Fairland
after William Henry Hunt
A Sleeping Nymph
Lithograph, 305 × 418 mm
British Museum, London

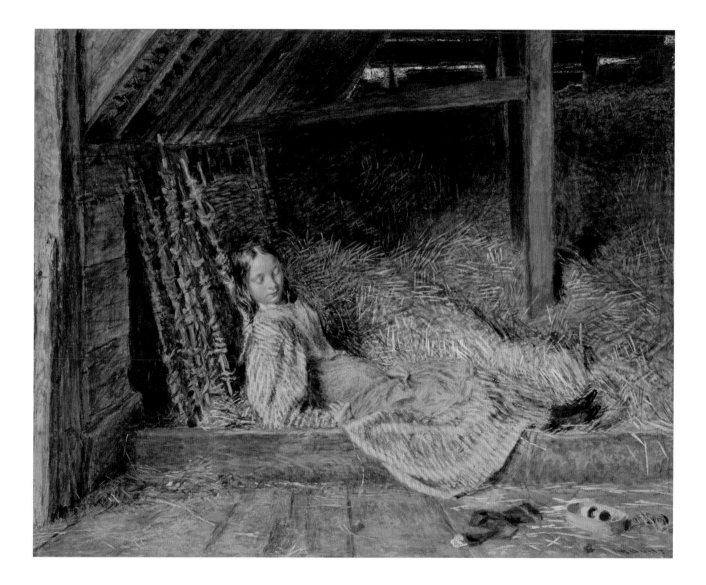

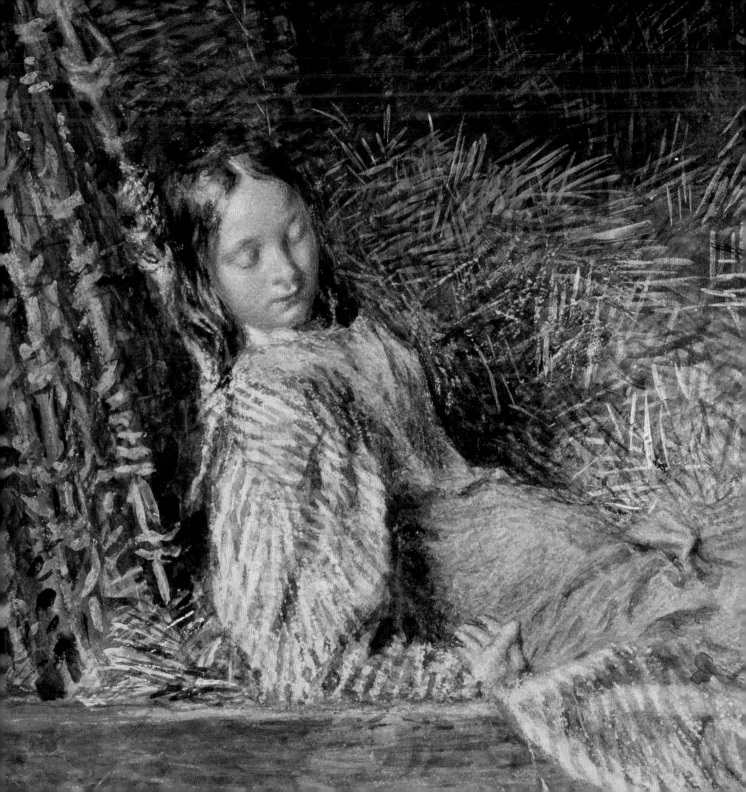

9 Jones 1981, no. 116, p. 56.

10 Collingwood 1898; quoted Jones 1981, p. 28.

11 Hardie 1968, p. 107.

12 The technique is admirably demonstrated by Hunt in his watercolour *The Contrast: Red and Green Apples*, JW697, Harris Museum and Art Gallery, Preston. For further discussion see cat. 13.

13 From J.J. Jenkins, transcripts of Hunt's letters and Mss notes, Royal Society of Watercolours Archive, J55, in Fenwick and Smith 1997, 'William Henry Hunt', pp. 184–88.

14 'Court Circular', *The Times*, 13 February 1866; Royal Watercolour Society Archive, J55.

trivial was a standard burlesque device", is as relevant to this group of images as it is to much else of Hunt's comic work.[9]

A mastery of colour, textural effects and play of light are admirably demonstrated in this drawing. William Collingwood's description of the artist's method of working could well apply here: "He began by putting on the paper what first struck him as necessary, generally with broad brush marks, which by degrees he broke down with smaller till utmost refinement was gained He went on and on with his work, seeing more as he went and doing more as he saw it, till he reached the goal."[10] As Martin Hardie noted, it is this method that helped to lend atmosphere to Hunt's interiors.[11] Over brown and yellow washes, Hunt has added finer details with the point of the brush, notably the spikes of straw hatched with white bodycolour, and scraped out patches of paper at the roofline to reveal daylight. Spots of red and green in the foreground are a subtle touch, indicative of Hunt's interest in the optical mixing of complementary colours.[12] He was recorded as saying: "It is astonishing the number of colours you can work into flesh",[13] and this is evident from the minutely stippled facial features seen here. In the opinion of his obituarist, "As a painter of flesh he was, perhaps, unequalled".[14]

The Orphan, c. 1848

Watercolour and bodycolour with some scraping out, on an extended sheet of paper, over graphite, 297 × 355 mm
Signed lower left: *W.HUNT*
Private collection
JW 388

NOTES

1 Possibly *Hearing Lessons*, JW. 536, Victoria and Albert Museum, London.
2 Whereabouts unknown.
3 Roget 1891, vol. 2, p. 196.
4 M.H. Spielmann, *The Royal Society of Painters in Water-Colours, A Retrospect, 1804–1904*, quoted in Witt 1982, p. 26.
5 Mingay 1977, p. 85.
6 See also cat. nos. 3 and 17. Hunt is known to have taken an interest in photography. On his death around 120 photographs were in his studio; see Jones 1981, no. 6, p. 8, and no. 53, p. 27.

FIG. 17
David Octavius Hill and Robert Adamson
Matilda Smith (née Rigby), 1843–48
Calotype, 212 × 156 mm
National Portrait Gallery, London

The fine finish of this watercolour and the soft shades of blue, yellow and red mark it as a work of the 1840s. From this period onwards single figures in cottage interiors were rare in Hunt's oeuvre. When he exhibited this scene in 1848, his other subjects were mostly children or fruit and flowers, and two birds' nests. Also included were *Rehearsing the Lesson*,[1] modelled by his wife Sarah and their daughter Emma, and *A Sister's Pet*,[2] which was possibly intended as a pair to *The Orphan*. Hunt was always more comfortable using family and friends as models than making formal portraits, commenting once on the difficulty he had painting Ruskin's wife Effie (subsequently Lady Millais): "I think I could have made a nice drawing of her if she had been one of my tramp girls".[3] Sarah is the model here and his sensitivity to her feelings shows in the naturalness of her wide-eyed expression. William Makepiece Thackeray recognised Hunt's skills when he wrote: "If you want to see *real* nature, now, real expression, real startling home poetry, look at every one of Hunt's heads".[4] By engaging the viewer with her face, Hunt attracts attention away from the pig. In so doing, he avoids the sentimental type of animal painting so admired by Victorian collectors.

For poor rural householders, the possession of a pig was a luxury, with its promise of meat and bacon, since a flitch or side of a hog could feed a household for months. William Cobbett, indeed, measured labourers' happiness by the number of their pigs.[5] By the 1840s, however, Hunt was comfortably well off from teaching and the sales of his work. His new-found status is reflected in this scene, with its neat interior of the type commonly shown in seventeenth-century Dutch paintings. Hunt portrays his respectably dressed wife, seated on a cushion, feeding a piglet as if it were a pet, rather than showing her in a dingy kitchen at work on domestic chores. Posed as if for an 'artistic' studio photograph, much in the manner of mid-1840s calotype portraits by David Octavius Hill and Robert Adamson (fig. 17), it would appear to be more of a Hunt family portrait than a representation of a generic 'type' of labouring housewife.[6]

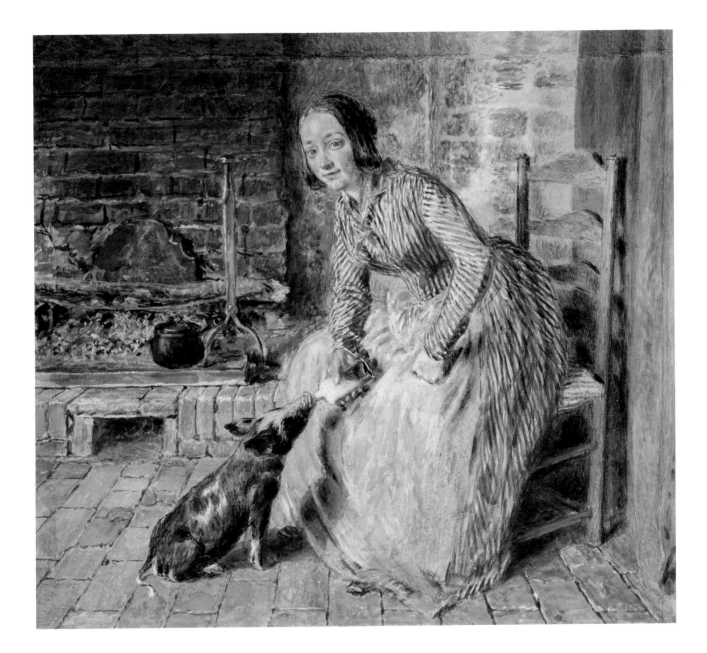

SELECT BIBLIOGRAPHY

Brian Allen, *William Henry Pyne and His Microcosm*, Stroud, 1976

Gillian Avery, *Victorian People*, London, 1990

John Britton, *The History and Description with Graphic Illustrations of Cassiobury Park, Hertfordshire: The Seat of the Earl of Essex*, London, 1837

William Cobbett, *Rural Rides* [1830], 2 vols., London, 1853

William Collingwood, 'Reminiscences of William Henry Hunt', *Magazine of Art*, vol. 21 (1898), pp. 503–05

Jennifer Davies, *The Victorian Kitchen Garden*, London, 1987

Charles Dickens, *The Magic Fishbone* [1867], London, 1911

Craig Eglund, 'Constructed Naturalism in the Watercolours of William Henry Hunt', *Huntington Library Quarterly*, vol. 53, no. 1 (Winter 1990), pp. 67–85

Jessica Feather, *British Watercolours and Drawings: Lord Leverhulme's Collection in the Lady Lever Art Gallery*, Liverpool, 2010

Simon Fenwick, 'Hunt, William Henry (1790–1864)' [2004]; online edn, October 2006, 1614 words, with portrait illustration: http://dx.doi.org/10.1093/ref:odnb/14212

Simon Fenwick and Greg Smith, *The Business of Watercolour: A Guide to the Archives of the Royal Watercolour Society*, Aldershot 1997, pp. 184–88

George Edmund Fussell, *The English Rural Labourer*, London, 1940

Edwin Grey, *Cottage Life in a Hertfordshire Village. How the Agricultural Labourer lived and Fared in the late '60s and the '70s*, St Albans 1934

Robert Havell, *A Series of Picturesque Views of Noblemen's & Gentlemen's Seats: with Historical and Descriptive Accounts of each Subject*, London, 1823

Martin Hardie, *Water Colour Painting in Britain*, vol. 3, London, 1996

Pamela Horn, *Life and Labour in Rural England 1760–1850*, Basingstoke, 1987

William Howitt, *Book of the Seasons*, London, 1831

William Howitt, *The Rural Life of England*, 2nd edition, London, 1840

Richard Jefferies, *The Game Keeper at Home* [1878], Oxford 1948

D.J.V. Jones, 'The Poacher: a Study in Victorian Crime and Protest', *Historical Journal*, vol. 22 (1979), pp. 825–60

Tom Jones, *William Henry Hunt*, exh. cat., Wolverhampton Art Gallery, 1981

John Claudius Loudon, *Encyclopaedia of Gardening*, London, 1822

Jeremy Maas, *Victorian Painters*, London, 1969, pp. 171–73

Jonathan Mayne, *Dr Thomas Monro (1759–1833) and the Monro Academy*, exh. cat., Victoria and Albert Museum, London, 1976

Thomas Miller, *Pictures of Country Life and Summer Rambles in Green and Shady Places*, London, 1847

Gordon Edward Mingay, *Rural Life in Victorian England*, London, 1977

Gordon Edward Mingay, *A Social History of the English Countryside*, London and New York, 1990

William Cosmo Monkhouse, 'William Henry Hunt', *Dictionary of National Biography, 1885–1900*, vol. 28, p. 282; https://en.wikisource.org/wiki/Hunt,_William_Henry_(DNB00)

Hannah More, *The Works of Hannah More*, London, 1801

J. Morgan and A. Richards, *A Paradise out of a Common Field: The Pleasures and Plenty of the Victorian Garden*, London, 1990

Toby Musgrove, *The Head Gardeners*, London, 2007

Christopher Newall, *Victorian Watercolours*, Oxford, 1987, pp. 31–32

Christiana Payne, *Toil and Plenty: Images of the Agricultural Landscape in England 1780–1890*, exh. cat., Nottingham Art Gallery, 1993; Yale Center for British Art, New Haven, 1994

Christiana Payne, *Rustic Simplicity: Scenes of Cottage Life in Nineteenth-Century British Art*, exh. cat., Djanogly Art Gallery, Nottingham, 1998

Prince Herman Puckler-Muskau, *Tour in Germany, Holland and England in the years 1826, 1827, 1832*

William Henry Pyne, *Microcosm: or, a Picturesque Delineation of the Arts, Agriculture, Manufactures &c. of Great Britain*, London, 1803–08

William Henry Pyne, *The Costume of Great Britain*, London, 1804

Harry Quilter, 'Jean Françoise Millet and William Hunt, or Idyllic Painting in France and England', in *Preferences in Art, Life and Literature*, 1892, pp. 177–82

Paul Rabbits and Sarah Kerenza Priestley, *Cassiobury. The Ancient Seat of the Earls of Essex*, Stroud, 2014

Samuel Redgrave, *A Dictionary of Artists of the English School* [1878], reprinted Bath, 1970

John Lewis Roget, *A History of the Old Water-Colour Society*, 2 vols., London, 1891

Ruskin, John, 'Notes on Samuel Prout and William Hunt' [1879–80], in E.T. Cook and Alexander Wedderburn (eds.), *The Works of John Ruskin*, 'Library edition', 39 vols., 1903–12, vol. 14, pp. 373–84 and 440–54; reprinted in Witt 1982, pp. 244–56

Ruskin, John, *The Elements of Drawing*, London [1857], in E.T. Cook and Alexander Wedderburn (eds.), *The Works of John Ruskin*, 'Library edition', 39 vols., 1903–12, vol. 15, pp. 25–228

Frederick George Stephens, 'William Henry Hunt (1790-1864)', *Fraser's Magazine*, November 1865, reprinted in *The Old Water-Colour Society's Club 1934–1935*, vol. 12, London, 1935, pp. 17–50

J.W. Tibble (ed.), *The Poems of John Clare*, London, 1935

Rosemary Treble, 'Hastings, William Henry Hunt', *Burlington Magazine* (1981), vol. 123, no. 941, pp. 502-07

Giles Waterfield and Anne French, with Matthew Craske, *Below Stairs, 400 Years of Servants' Portraits*, exh. cat., National Portrait Gallery, London, 2003

Byron Webber, *James Orrock, R.I., Painter, Connoisseur, Collector*, London, 1903

Raymond Williams, *The Country and the City*, London, 1973

John Witt, *William Henry Hunt (1790–1864): Life and Work, with a catalogue*, London, 1982

A. Young, *General View of the Agriculture in Hertfordshire*, 1813

ACKNOWLEDGEMENTS

I would like to thank Ernst Vegelin van Claerbergen for inviting me to curate this exhibition of watercolours by William Henry Hunt, a favourite artist of William Clarke, The Courtauld Gallery's Paper Conservator from 1978 to 2008, and kind friend and colleague, to whom the exhibition is dedicated. I am especially grateful to William's wife, Elizabeth, who assisted in the choice of a drawing for the Gallery to acquire in his memory, and to Lowell Libson's suggestion of *The Head Gardener*, a particularly fine example of the artist's work, around which the present exhibition is based.

Most importantly I would like to thank Shirley Fry and her family for insights into the watercolour collection of Cyril Fry. My research has benefited from collaboration with Christiana Payne, whose specialist knowledge and advice I have greatly appreciated. For further research assistance and access to collections I am grateful to Luke Bonwick, Jeremy Burchardt, Luke Clarke, Hatty Davidson, Jennifer Davies, Oliver Douglas, David Frost, Colin Harrison, Christopher Hasler, David S.D. Jones, Tom Jones, Rupert Maas, Briony Llewellyn, Christopher Newall, Charles Nodder, Guy Peppiat, Sarah Priestley, John Robertson, Martin Watts, Timothy Wilcox and Jonny Yarker, among others. As a visiting curator, the support I have received from The Courtauld Gallery staff has been invaluable. Thanks are also due to Laura Parker for her design and to Paul Holberton for his editing skills and patience, and to John Witt's extensive catalogue raisonné, without which no student of Hunt's work could begin.

JOANNA SELBORNE

PHOTO CREDITS